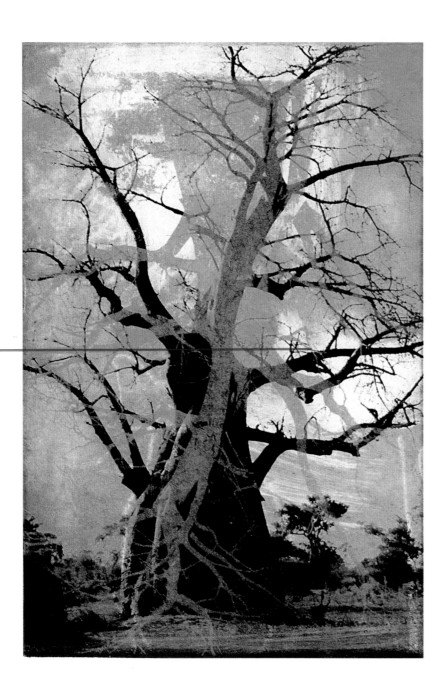

new art
INTERNATIONAL

A Compendium of Recent Works
by World Contemporary Artists

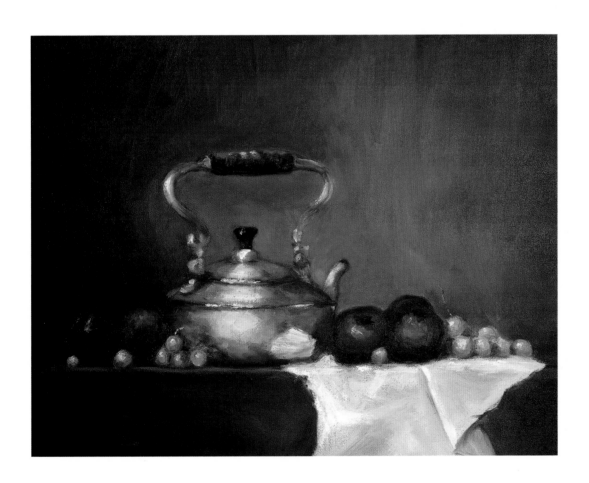

Book Art Press • Publishers • New York
Volume XI 2006-2007

Front Cover:
APRIL BENDING

Back Cover:
LAWRENCE RALSTON HUGO

Frontispiece:
L. NOEL HARVEY

Title page:
PAT BALDINO

Executive Editor: Jeremy Sedley
Managing Editor: G. Alexander Irving
Contributing Editor: Olivia Twine
Production: Natalie Gains
Graphics: LuAnn Arena
Assistant Editor: Danielle Reisigl
Assistant Editor: Nicole Digilio
Curator: William La Mond
President: Leslie McCain
Publisher: J. S. Kauffmann

Published in the United States of America
in 2006 by Book Art Press, Ltd.

New Art International
Copyright ©2006

ISBN 0-9773540-2-4 0-9773540-3-2 (pbk.)

CONTENTS

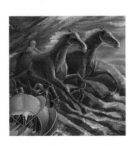
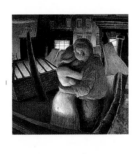
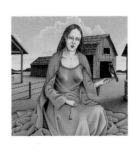

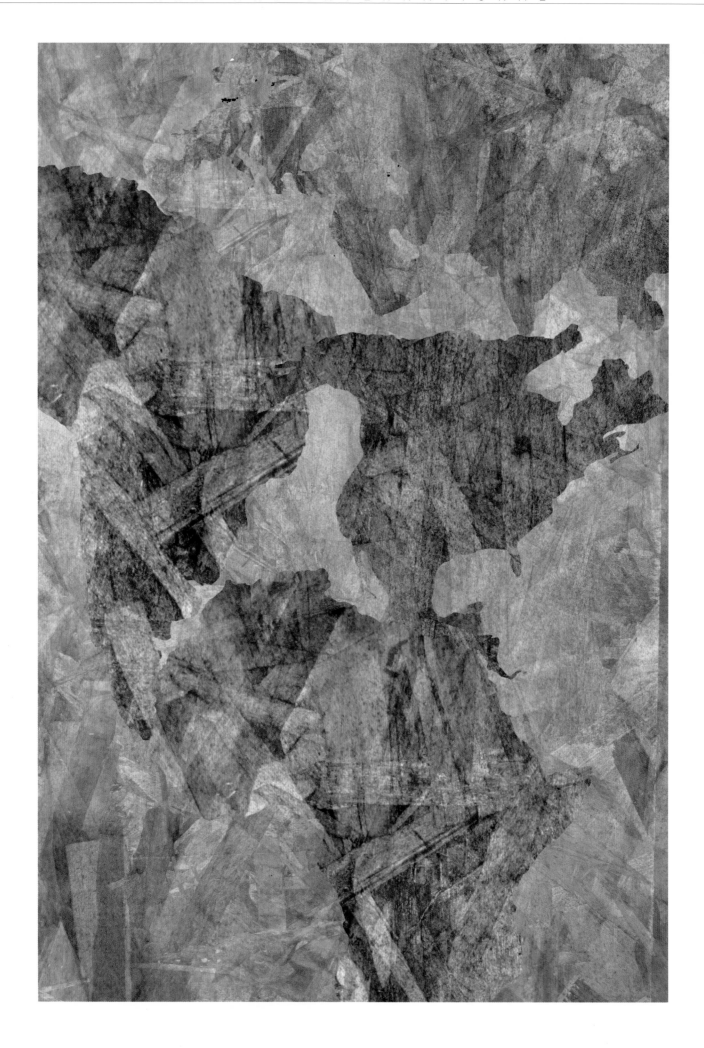

Dear Barney,

I'm not going to use your right name and this E-mail will, of necessity, be cryptic but it's in your mailbox, so you have a headstart toward figuring out who's reading it.

It all began with an innocent quip on the phone. I was speaking with Joe (not his true name) about motion picture arts and I mentioned *From the Terrace* as one of the movies that Paul Newman did not act in. Of course, he had a starring role in that 1960 Turkey of the Year but that didn't seem to influence his performance. Unlike today's movies– like *Snakes On A Plane*, where the title is also the plot– Newman's vehicle had the literary pretension of a John O'Hara novel. Young Paul, however, made the mistake of working from the script.

Regardless of that, as soon as I said "From the Terrace," I heard a click on the line but, unconcerned, I continued on about artistic formulas and the staleness of repetition and I used the term "art conspiracy" in reference to the marketing of style and Foucault's book on the excuses of power. I hadn't the breeziest notion that I might be triggering something but when a kind of whirring sound began to issue from the distance outside of the office window, I began to feel a sense of unease.

Instinctively, I steered the conversation away from Mark Lombardi's diagrams and Jean Baudrillard's book *The Conspiracy of Art*. I mean, if you had a choice, who would you want to offend first– artists, dealers or buyers? I changed the subject to a song cycle by the pop group The Happy Bullets.

Okay, okay. Maybe that's *too* cryptic but I was getting more nervous by the minute; edging toward panic with a shuffling sort of sidestep. Not the PANIC Michael Tye discusses in *Consciousness, Color and Content*– "Poised, Abstract, Nonconceptual, Intentional Content"– but more the kind of feeling Zeno the Stoic defined in 256 B.C. This was very primal.

That night, as I was drifting off to sleep, I was thinking about remarks made before New York City's Committee on Cultural Affairs by Randall Boursheidt of the Alliance for the Arts in early 2006. He spoke movingly about the difficulties faced by immigrant artists in the City who wish to pursue their vocation in their new environment. I thought about Princeton's Professor Douglas Massey's comments about an exhibition of Mexican immigrant art he had collected for display at the University; "It's popular art and, while some of it's *déclassé*, it depicts a social phenomenon." *Déclassé* indeed!

I thought about the contributions to the very foundations of American art brought by artists arriving from foreign shores, like Gustaf Hesselius and Lars Sellstedt from Sweden, Thomas Cole from Great Britain, Haitian-born James Audubon or the French, Dutch, German and on-and-on gifts of artist fiber from cultures elsewhere which wove a collective identity into American art... But wait, I thought, is there really an "American Art"? What could be more individualistic than personal creation? Is there a definitive "European Art?" Where do we join the rigorous academic preparation of the Russian school to the calculated abandon of the German Expressionists? What perimeters are we considering? Are we speaking of ethnic, cultural flavors– Asian? Latin American? African? Australian? Well, maybe not Australian, mate.

A 2001 census found 26,400 immigrant artists in Canada, up 31% from the previous decade and representing 20% of all Canadian artists. Their reception, in terms of earnings, were dramatically better on average than immigrants to America. This made me even more nervous.

I thought about the effort of this series, celebrating INTERNATIONAL art, to consider creativity beyond the distinction of national borders. Maybe that was it. Perhaps that was behind the unease I was feeling. Perhaps we weren't being American enough in our focus?

Just then the door to the apartment flew off its hinges and boots pounded toward the bedroom. Glaring lights blinded me to anything but dim forms circling the bed and harsh questions about what I got from "them."

"From 'Them' whom?"

"You know who!"

Suddenly my head was in a pillowcase and I was being rushed away.

By dawn, I was strapped into a nightmarish boatride in a sweaty, bat-filled tunnel somewhere near Orlando and the shouting continued as I cowered in my bright dayglo canvas pajamas. The rest is a blur.

I remember a shadowed face leaning over me with a medal of Saint Dominic the Inquisitor dangling from his neck, catching the light as other shadows scurried about doing unspeakably painful things to my biological attachments. One shadow had a snake nose and a "wiolawa" button and I cried out "Where is Scully now that we really need her?" You're right, too cryptic again. But there's a reason.

Somewhere during the seventh month, as I was being grilled on what they thought I might know about the art conspiracy, I screamed out an admission that modern art is a hoax. It isn't, of course, but I had given them what they wanted.

After the sedatives wore off, it took weeks before the quivering subsided and months more of healing back in the wintered Catskills before I could begin to rationalize what I had done. That's why you haven't heard from me.

I had a debt to pay to the world of art and I finally figured out how I could do it.

What if, I reasoned, what if instead of a representational introduction to this year's book of fine, new art created by artists from anywhere at all, I wrote an *abstract* introduction? Would that, in some small way, make up for my "confession" about modern art?

Well, it would have to do, I decided as I lit my cigar, stuck a tube of gesso into my shoulder holster and put my feet up on the desk. Then I did what any other brave American soul would do in the circumstances. I waited for things to change.

—*J.Sedley*

Invitation for Life 72" x 96" Acrylic on canvas

Kendra 61" x 134" Acrylic on canvas

Creation 48" x 48" Acrylic on canvas

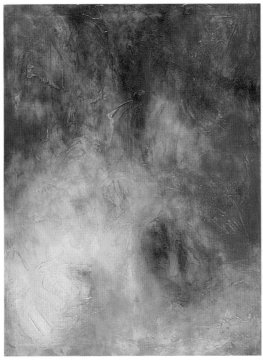

Tranquility Acrylic on canvas

FERNANDO DE OLIVEIRA

Using traditional techniques and acrylics on canvas, Fernando DeOliveira uses color and texture to communicate with the viewer. Born and raised in Brazil, he worked as an artist and an art dealer for many years before moving to the U.S. in 2000.

In 1991, he received his B.A. degree from the University of Curitiba, Brazil. Later, he studied in Boston, Ma. at the School of the Museum of Fine Arts, Atelier Thomas Oullette, and at the Worcester Art Museum in Worcester, Ma. Among many solo and group exhibitions in Brazil and the U.S., his work was recently shown at Colwell Banker in Jamaica Plain, Ma., the Boston Public Library, and at Black Rock Art Center in Bridgeport, Ct.

Though all the images are abstract, the feelings provoked are very real, and, despite appearances, there is a very rational structural solution that brings the public to my pictorial world, to my dimension.

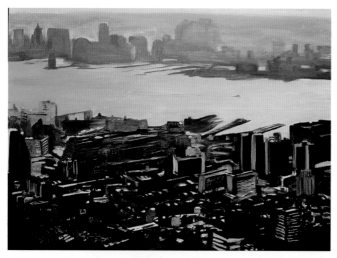

River 36" x 48" Oil on Canvas

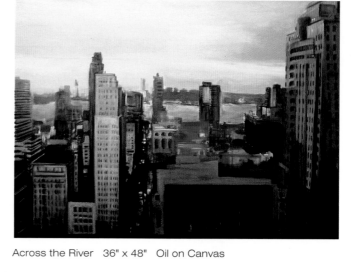

Across the River 36" x 48" Oil on Canvas

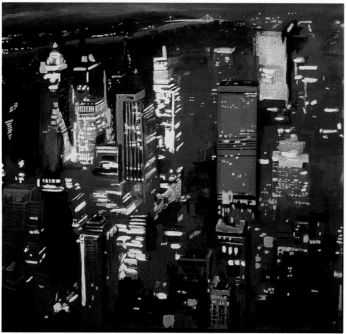

Manhattan Mist 80" x 84" Oil on Canvas

MOUNIRA STOTT

A native of Moscow, Mounira Stott has evolved from research scientist to artistic interpreter of American cities. She graduated with high honors from the Moscow College of Artistic Professions in 1992 and experienced success as a painter before immigrating to the U.S. in 1999.

Stott earned an M.F.A. from Western Connecticut State University in 2004 and completed a residency at the Vermont Studio Center the same year. She has studied with Margaret Grimes, Marjorie Portnow, Hugh O'Donnell, Stephen Brown and John Wallace.

As a result of solo and group exhibitions in Connecticut and New York City, Stott's works are among the collections of the National Museum of Fine Arts, the Presidential Palace, the national Conservatory and the Ministry of Culture of Tatarstan, Russia; The Orange Cat Studio in New Milford, Ct., and numerous private collections in the U.S. and Europe. She won the Award of Excellence from Manhattan Arts International in New York City in 2004.

The modern city is a fantastic place filled with life, light and excitement—the center of culture, activity— pervasive energy. This is the place of mankind's greatest creations. The buildings are huge monuments—gigantic sculptures. More than any other city in America, New York evokes the monumental sense of a city. My paintings explore a range of new ideas with perspective and color to present the city more powerfully.

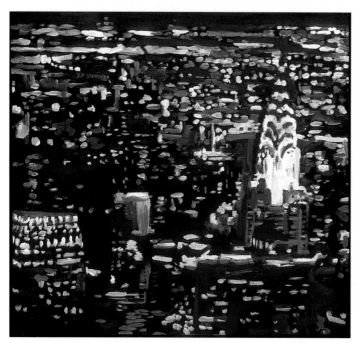

Chrysler Night 24" x 24" Oil on Canvas

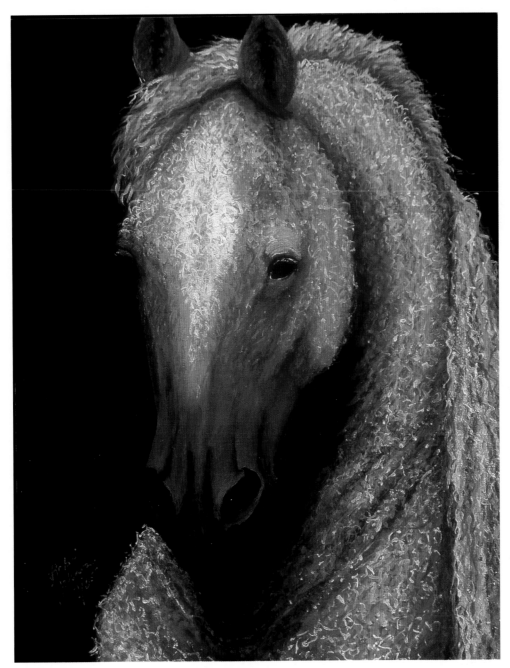

Pose for the Camera 12" x 16" Acrylic on plywood

ROBERTA "BOBI" JOHNSON

Roberta "Bobi" Johnson has been fascinated by the creative process from an early age, as she observed her mother painting. She began her own art career when she was nine years old, everyone in her family received gifts of her original macramé wall hangings and planters. By the time she reached fifteen, she was teaching macramé classes in a Houston, Texas arts and crafts shop. Customized pieces were popular with shop customers. Also, under her mother's tutelage, the budding artist began to dabble in oil painting.

After getting married, raising 3 children and working for 25 years in sales and marketing, Bobi studied drawing at College of DuPage in Glen Ellyn, Illinois. She resumed her painting career in 2002 and is now emerging into the art world. Her paintings, although often of horses, are to be viewed as social commentary.

I use equine art to help viewers see the social vagaries and inequities of our society. Using animals helps viewers stand back from themselves, see themselves in a different way, and consider for a moment how others may be seeing or feeling about them. I paint for joy, but I hope my images have an impact on society by making others, if only momentarily, more gracious and merciful to one another.

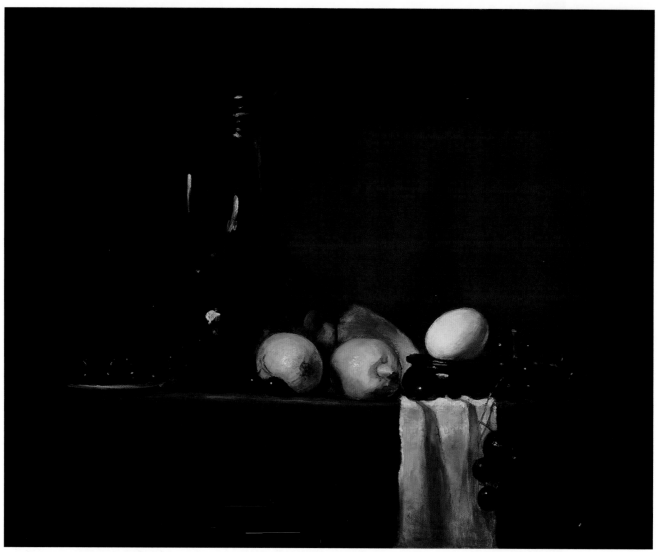

Two Lemons ?????" Oil on canvas

PATT BALDINO

With an emphasis on contrast, fruits burst with color against the rich tones of an earthenware pot. A shapely metal teakettle shines amidst gem-like grapes and deep garnet apples. Homely cloves of garlic, an enraptured orchid, a blue-patterned bowl, an egg; all are highlighted in Patt Baldino's distinctive still-lifes.

Sensitivity combines with technical skill to bring the artist's subjects to life. Objects that are more than decorative emerge provocatively from darkness, enticing the viewer to look closely. In *Brown Jug with Garlic*, a spot of light reflected from a jug in the background draws the eye from a root of fresh garlic into the mysterious unknown. A similar effect is created in *Two Lemons ?????"*, wherein light from a glass decanter recedes behind palpable lemons and a perfect egg.

Baldino can be compared to Vermeer in her use of light, to James Peale in her elegant composition, and to the seminal Dutch painters of the 16th century with the simplicity of emotion her work inspires. *Orchid in Bloom* stands apart from the other paintings she exhibits here in that the plant is unaccompanied by other objects except for the simplest of pots on the subtlest of tables, its beauty barely constrained to the earthly dimension.

Patt Baldino started painting at the High Scholl of Art and Design and went on to earn an Associate Degree from the Fashion Institute of Technology and a BFA Degree from the School of Visual Arts. She also studied at the National Academy of Fine Art, the Art Students League, the Reilly League of Artists, and other fine teaching establishments.

Her work is presently exhibited in the Phyllis Lucas Gallery in New York City and the Christopher Gallery in Stony Brook, N.Y. During 2005 and 2006, her paintings were shown in UpStream Gallery Miniature Art Shows and at the National Academy Museum.

Using a view finder really helps to get the layout I want. Unlike a landscape, I want the viewer to immediately focus on the center point and trail off from there. The focal point needs to be strong.

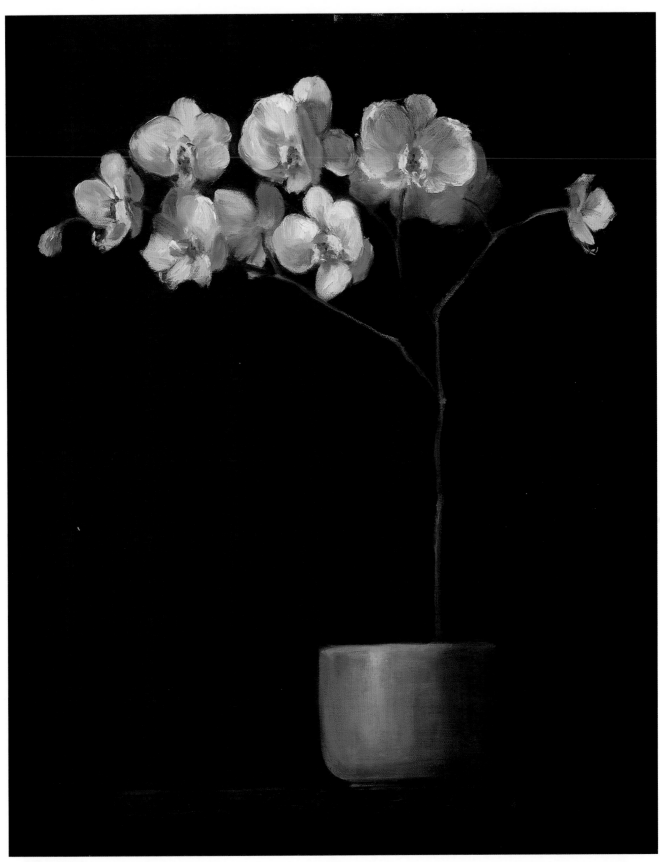

Orchid in Bloom 16" x 20" Oil on canvas

Brown Jug with Garlic 16" x 12" Oil on canvas

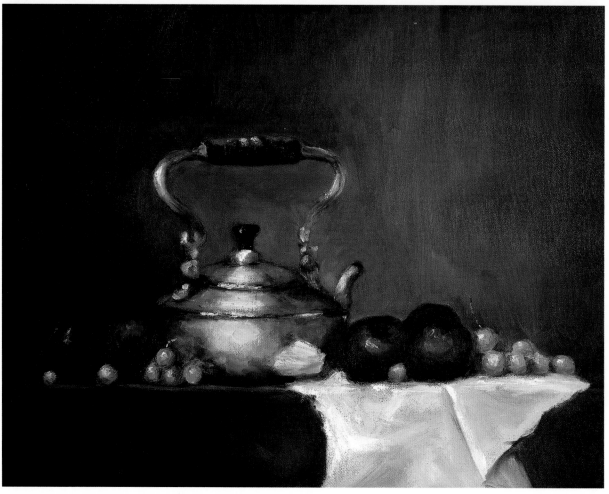

Gold Teapot 20" x 16" Oil on canvas

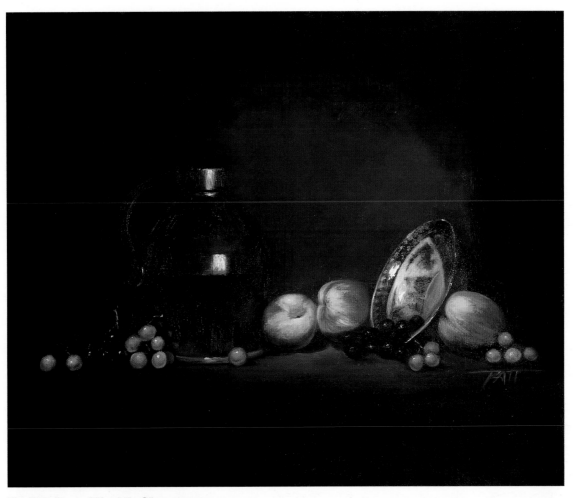

The Blue Bowl 20" x 24" Oil on canvas

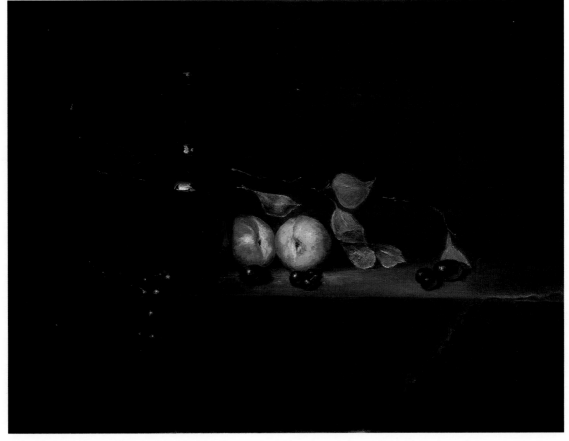

Two Peaches 18" x 24" Oil on canvas

PATT BALDINO

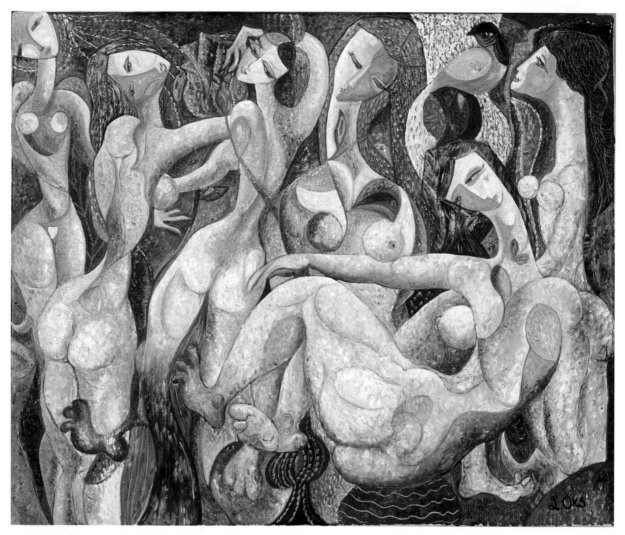

Jealousy I 30" x 36" Oil on Canvas

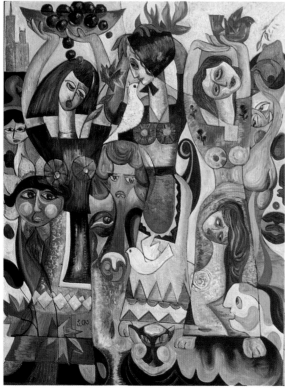

Peace 60" x 46" Oil on Canvas

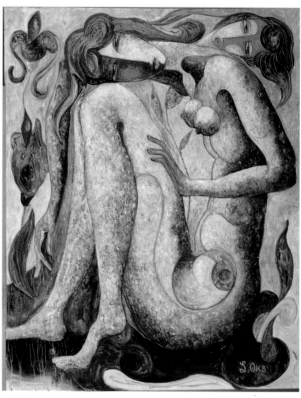

Dreams I 30" x 24" Oil on Canvas

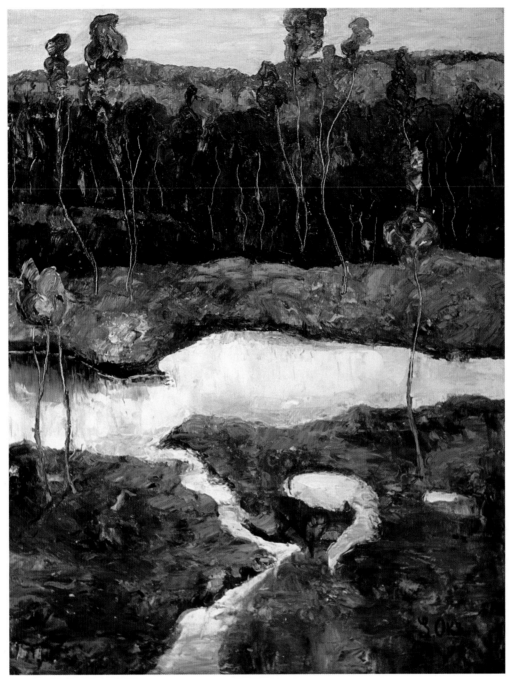

Autumn in Massachusetts 28" x 22" Oil on Canvas

LEON OKS

Russian-born artist Leon Oks possesses an exceptional vision, and he expresses it through the form, fluidity and color of his paintings. He combines dynamic movement and multiple perspectives with an emotionalism that reveals joy and sadness in equal measure.

The artist has been featured in one-person and group shows across America and in Europe, receiving many First Place awards. The International Biographical Centre of Cambridge, England nominated Leon Oks as an International Visual Artist of the Year 2004 and selected him as one of the Top 100 Contemporary Artists of 2005.

He won First Place in "International Summer Show" at the Latin American Art Museum, 2004; in "Encounters," at the Museum of the Americas in Miami, Florida, 2004. He received the Diploma of Excellence in the Global Art Annual "Competition, "Art Now," London, 2005; and also First Place International Competition "Just Paint 2005" at Artrom Gallery, Rome.

As a painter, I capture the essence of images. Deep feelings intertwine with colors and shapes, which flow lyrically on canvas and convey a truth about our existence.

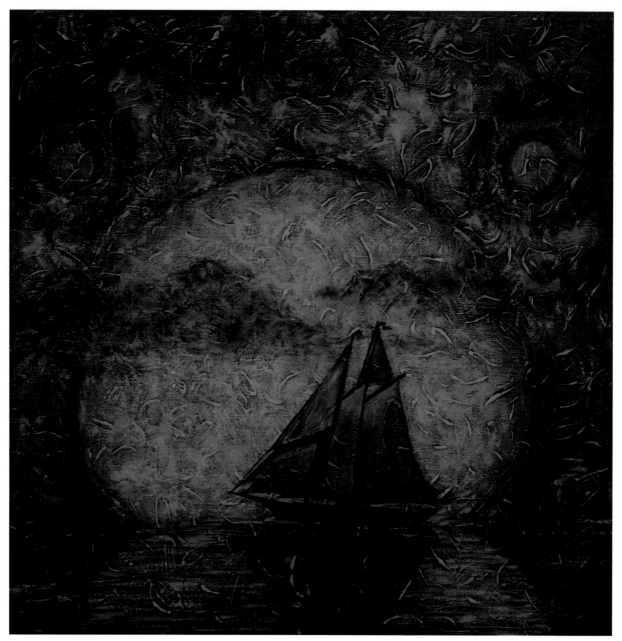

Sunset on an Era 24" x 24" Oil on canvas

April Bending: A Quest for the Natural within the Beautiful

April Bending conveys a sense of life on earth as a human-mediated phenomenon—while at the same time, paradoxically, she calls into question our native inclination to place humanity above all.

Bending lives and works in Grand Cayman, where mangrove swamps and coral shorelines provide her an ecological vantage that is almost microcosmic. Her figurative subjects, one might suggest, are emanations at points where the ocean's formless density comes to a momentary end.

Ancient Mariner portrays a fish. The title itself makes the connection: this elegant specimen is our ancestor and our equal. Bending's fish, in the carved quality of its lines, may at first remind the viewer of an animal drawn on Mesolithic rock. But then in its peculiar stasis, the design reveals a more modernly precise hand and eye—so that instead of mallet and chisel, an architect's drafting pencil is brought to mind. The fish is set against two concentric circles, which in terms of proportion represent an iris and pupil. An eye, undoubtedly, is a semaphore in the consciousness of fish. Bending's picture, though, raises another possibility; for the circles can also be viewed as planetary objects. A fish, after all, may well be more deeply aware than people are of the round glow of the moon and changes in diurnal light. The turns and slants of our solar system may be engrained in a fish's psyche beyond what we can imagine, may inform its mariner's compass.

Seekers II 48" x 24" Oil on canvas

Seekers I 48" x 24" Oil on canvas

All life in our planet's biosphere is in a perpetual state of interaction—and the rest of the universe is involved in this process too. Bending's *Sunset on an Era* induces us to meditate on the very immensity of life and existence within which human commerce and civilization are but an immeasurably small part. Pictured simply is a sailing ship and a giant sun. The galactic effulgence that suffuses the painting with red is sullen and quiescent as it spills a primeval tint onto the ocean. The triangle of the boat as it passes in front of the solar disk may call to mind a sundial; hence, the advancing skills of human precision—measurements of time, nautical distance, profit. The era of sailing ships on which Bending muses was one that made a close connection between rational order and geological and celestial wonders. The sentiment of *Sunset on an Era* brings to my mind a stanza from the poem *Cargoes* by English poet John Masefield:

The human figures, in the paintings titled *Seekers 1* and *Seekers 2*, are occupied in thought, but on the verge of action. Thought and action, in fact, are nearly undifferentiated here—and, it feels, are united in a concept of a human ideal. The faces are indistinct, germinal. The bodies, behind a pale film that looks like photosynthetic matter, seem almost prototypes of the human form. And though there is nobility to their aspect as thinking, questing creatures—seen as they are, beneath a translucent, organic gel, the figures appear subsumed by larger processes of life. Their protean character and charm, nonetheless, are not lessened. Bending's study perhaps even goes so far as to showcase an epic dimension. Roused to a decision, the seekers cannot wallow in contemplation anymore than they can know the journey of their own thoughts.

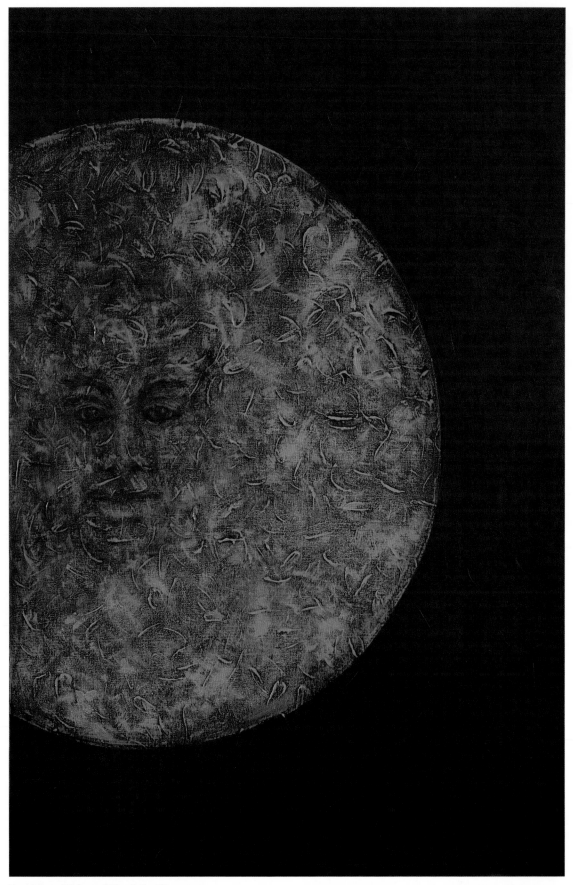

Red Moon Rising 36" x 24" Oil on canvas

APRIL BENDING

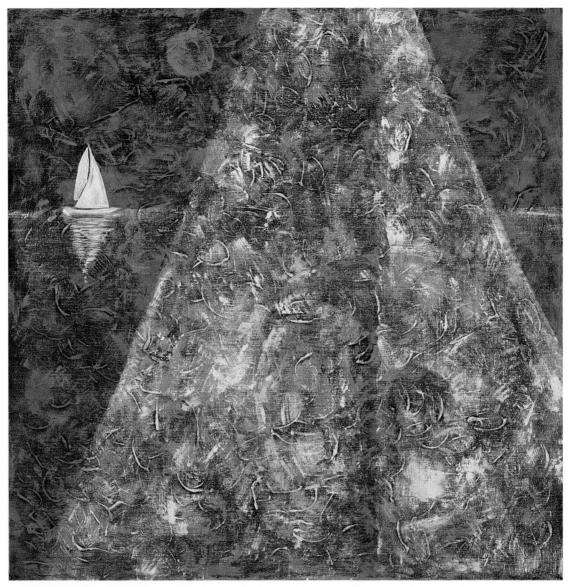

Moonlit Sail 24" x 24" Oil on canvas

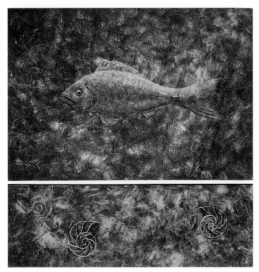

Peaceful Passage 36" x 36" Oil on canvas

In *Red Moon Rising* the moon possesses an atypically personal face. It is not the customary anthropomorphizing projection, the man in the moon that everyone at one time or another has discerned. It is small, vivid, and androgynous. Indeed it is a face that—were one really there—could be there even if there were not a single person alive on earth to observe it. Also, the likes of this moon's molten red glare have never been seen—nor will ever be, unless there is a drastic recombining of the earth's atmospheric gases. Against absolute blackness, it is as if viewed from outer space. It is a transmission of our world from the void of our world's existence; a harkening, a shadowing forth. The picture's essence might be likened to the question raised in a well-known Zen koan: "What did your face look like before your parents were born?"

It is a very different moon, a reserved force, that controls the pleasant state of affairs in Bending's *Moonlit Sail*. This moon is doubled by its reflection on the water, and the two moons together for a moment are like wheels in a mechanism. A simple sort of science dominates the

APRIL BENDING

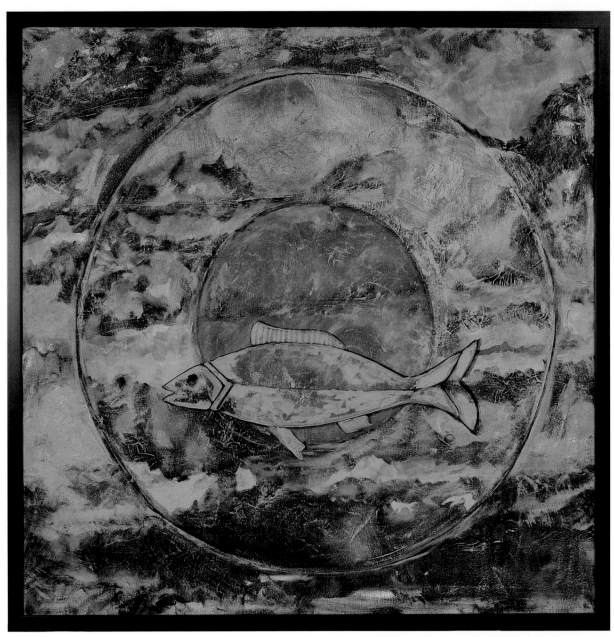

Ancient Mariner 24" x 24" Oil on canvas

picture. There is a vanishing of all uncertainty. The elements—the currents, the breezes—are off duty. Circles, triangles, and the trigonometry of the ancients prevail. The secrets of navigation, for people and fish alike, are communicated from above.

The light that illuminates the top of the fish in Bending's *Peaceful Passage* filters through green algae and layers of alimentary systems. The fish's eye in turn is alert, as if it is intending to capitalize on increased visibility. Underneath the fish are soft-bodied marine animals. Their shapes perhaps are an allusion to microbial life of the earliest eons. In any event, an evolutionary linkage is apparent—the idea that individual and species are subsumed in the widest network of life.

Human habitation of the Cayman Islands is relatively recent. There is no evidence of a pre-Columbian community. For generations the principle occupation of its settlers was fishing. The islands are small to the point of raft-like. It is easy to imagine that sun, moon, and ocean would be felt on a scale that might be daunting; one's sense of selfhood could come into question; but on the other hand, what an opportunity for someone aspiring to a nexus of nature and beauty. Coming from this place, April Bending touches our senses—and in doing so she revisits the story of our species, and touches our mind.

—*Marx Simao*

APRIL BENDING

Fish Primaevil 12" x 12" Oil on canvas

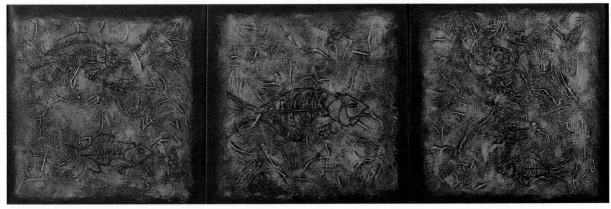

Impressions on a Cavern Wall 12" x 36" Oil on canvas

APRIL BENDING

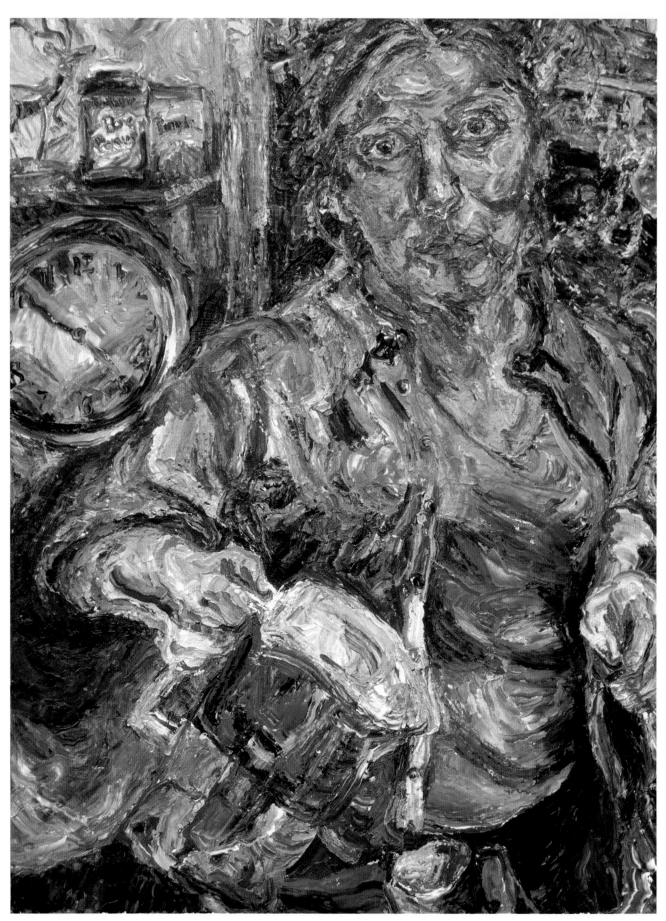

The Filtering Pitcher 47" x 36" Oil on canvas

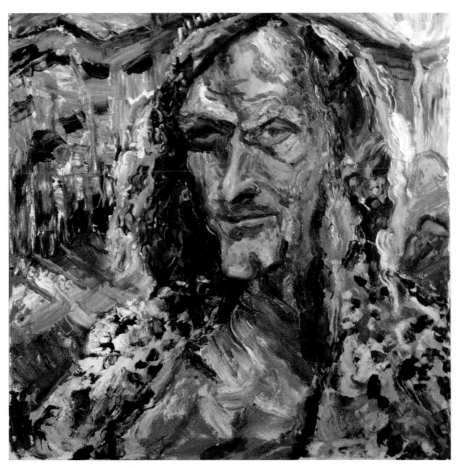

Freedom Warrior 30" x 30" Oil on canvas

LORRAINE FLORENZE NEVERS

A native of Summit, New Jersey, Lorraine Florence Nevers is a contemporary oil painter who earned a B.F.A. from Fairleigh Dickinson University. She also studied at the New Jersey Center for Visual Arts.

Her work has been seen in New Jersey in a one-person exhibit at the Shering-Plough Corporation. She has exhibited her works in New York City with the "Street Painters" at the Cork Gallery of Lincoln Center.

I believe in painting the energy, rhythm, moods and textures that one can feel from the 'life' of a subject. I don't demand that at subject hold still, but prefer, in fact to paint a figure that is moving, changing, talking, blinking, gesturing, etc., because this way I am challenged to respond to life's reality.

Hunger 42" x 42" Oil on canvas

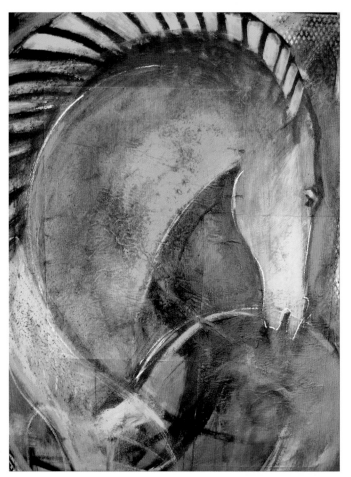

Sunset Stallion 48" x 36" Acrylic on canvas

Ice Dreams 40" x 36" Acrylic on canvas

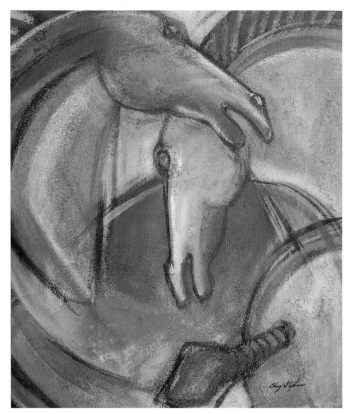

Spring Romp 36" x 36" Acrylic on canvas

CLAY STEPHENS

Movement, energy and passion infuse Clay Stephens' contemporary abstract expressionistic paintings. The Florida-based artist works boldly, using a colorist approach. He is experienced in the use of oil, watercolor, batik, charcoal, pastel, pottery and creates sculpture. His is preferred media are acrylics on canvas and mixed media on paper and canvas.

From 1995 to 2001 Stephens spent time traveling, attending art workshops and working in the interior design field. Now he is pursuing a full-time career in art. He has had solo exhibits and juried shows at galleries all over Florida, including Sarasota, Boca Raton, and Vero Beach. Stephens' work appeared also at Two Dogs Gallery in Rigeway, Colorado in 2005, and at the Brevard Museum of Art and Science in Melbourne, Florida in 2003. His paintings are part of corporate and private collections throughout the United States and abroad.

Art is a journey, each painting is another mile towards my destination. Each canvas is another adventure. The chance for discovery and growth is very exciting.

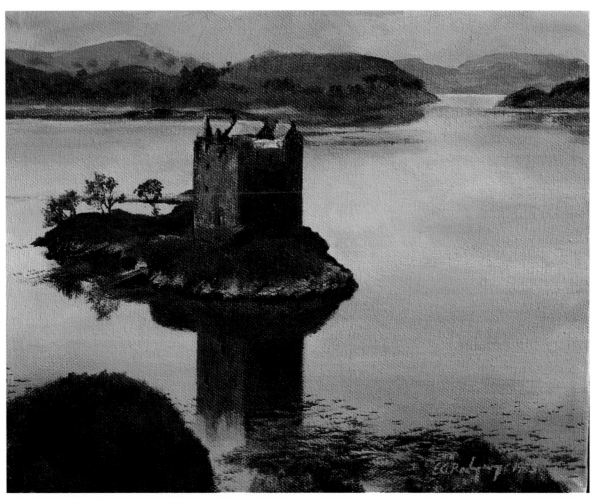

Still 8" x 10" Acrylic

Burst 24" x 18" Mixed media

ERNESTO A. RODRIGUEZ

A prodigy, Ernesto Rodriguez started creating art at age three; instruction began before he was nine years old. He won his first art scholarship while in the fifth grade, culminating in his first show at the age of ten at Alexander's Department Store in the Bronx, N.Y. By the time he reached seventeen, he had studied art at the Museum of Modern Art, the YMCA and the Art Students League of New York. He won his high school's Citizenship Award, largely due to his artwork. Scholarships materialized for study at Parsons School of Design in New York City, where he earned an A.A. degree. He obtained a B.F.A. degree from the New University, also in New York City.

Ernesto Rodriquez' work has been exhibited in the U.S., South America and Europe, and is in private collections. He has taught at Saint Francis of Assisi in New York City and at other private, parochial, and public schools. He has researched Hieronymus Bosch and Paul Klee. His achievements are noted in Who's Who in America, Who's Who in American Art, and Who's Who in the World.

Art and its creation encompasses most of the arts and sciences all at once. Realizing art messages in art requires one not being satisfied with the first or second attempt. Seeking beauty, hope and love is not enough, save for the constant and persistent pursuit of such, persevering daily.

Moment 24" x 36" Oil on canvas

Raissa Latych's Links of Imagination

The logic of intuition lurks dreamlike in the recent works of Raissa Latych, conveying its symbolic languages in frequently subdued tonalities of abstraction, representational and expressionistic folk fantasies queerly perched in the challenged terrain between man and nature. Punctuations of cultural posture, often represented by musical allusions, strive to position themselves to extenuate intrusions of technology and its threatening byproducts as birds, insects and beasts linger cautiously amidst the waves and streams of man-driven event in dreamscape reflections of an underlying reality.

Metaphorical beams of light play against flows of current, unmasked sometimes as fumes, which swirl their unheeded presences around activities mysterious and mundane. In one painting, a metronome measures its own pace against the breaking waves of an ocean's edge while in another, aspirations, medievally cloaked in human form, play their mitigating chords through cracked and tilted buildings. Alternately, there are busy gardens and ghostly travelers in train stations presenting enigmatic views of an historic accounting, the final sums of which are tallied only in the secret books of artists.

Currently teaching at the School of Art in Moscow, a position she has held for 16 years, Raissa Latych was born near Stavropol, an industrial city of less than half a million inhabitants in the Russian Caucasus Mountains that was founded as a fort and produced such celebrated figures as the political leader, Mikhail Gorbachev. A graduate of the Industrial Art College of Moscow, she earned her Master's degree in Art from the Stroganoff Institute of Art in 1968 as she worked as an illustrator for a film company and a graphic artist for Pravda and the German newspaper Nues Leben.

Minstrel 39.5" x 31.5" Oil on canvas

Muse 39.5" x 31.5" Oil on canvas

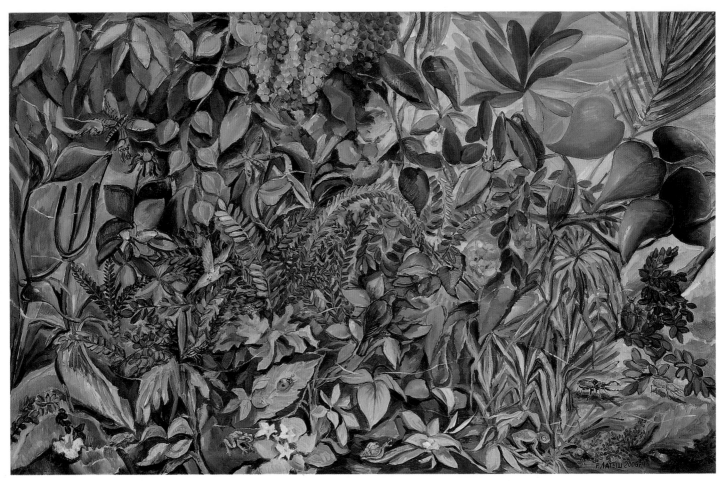

Forest 37.5" x 59" Oil on canvas

"All of her life, starting from childhood, has revolved around nature," explains Latych's daughter, Elena Ganjoula, a resident of California. "She grew up in a rural village with a love of the farms and fields, so, many of her paintings have environmental themes. Some, you can see, showing the abundance of fruits and vegetables in the richness of the California harvest; the Sunshine State. But her idea of art runs much deeper than the environment because, if you look at her artwork, you'll see it blends realism with philosophical freedom and her understanding of the world's maturity. It views the relationship between people and nature...

"If you look at her tree trunks, they look like sculptures. It's sort of like they're human bodies, the way they interact with each other-they're full of character and the scenes are filled with symbolism. Mountains as a symbol of hope; water and clocks as symbols of time; green apples to represent the things people do in life that are far from perfect and ladders, like in the Bible, are there to climb toward a better life, a better hope."

As a child, Raissa spent countless hours exploring the natural world in the variety of places her father's role as an army officer brought the family. She learned the craftsmanship of the saw and hammer in her grandfather's workshop. An appreciation for the bristling air between creation and construction seeped into her senses and a lively trace of jazz in Russian restaurants helped set a spirited backdrop for her student years. Latych's college project, "The Costume of Peter the Greatest" was honored with awards and a short documentary film about it previewed major movies in Russian theaters. Her thesis was published in full by the popular magazine Youth and a later scholastic project, "Mobile Doll Theater" was published in the trade magazine Theatrical Design Techniques and is still used on the cover of Pravda.

Raissa Latych received widespread notice for her design work on toys and with the popular Moscow Doll Theater, even designing such humanly interactive devices as camera bodies and other technological appliances. Her attention to such configurations inevitably found their way into her paintings and a review of her work from early exhibitions yields the figures of dolls and toys within a number of that period's compositions.

RAISSA LATYCH

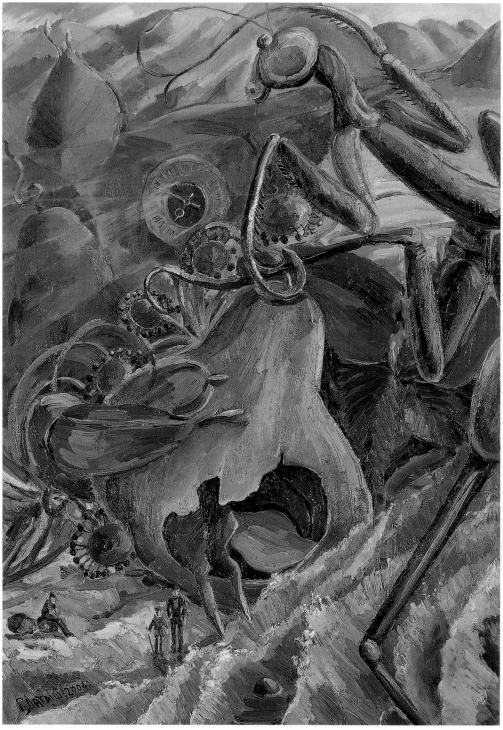

Squash 28" x 20" Oil on canvas

"There were efforts in that period to portray the child's outlook on the world," Ganjoula elaborates. "The toys would be Russian dolls made of clay- like little horses, teddy bears, real dolls, tiny dogs; dwellers of the imaginary world that children populate with princes, princesses, castles and the like. Basically, what she tried to portray was the innocent mind of a child and a pure outlook on the world. Some of it, because of me, was autobiographical and a mother-daughter theme occurs here and there."While presiding as the General Manager of the principal art gallery of Krasnogorsk, a suburb of Moscow renowned for its film making and camera manufacture, Latych designed the stone statuary which still stands as a landmark of cultural grace at the gates of the city. She was also commissioned by a scientific research company, in this period, to create three murals of 30 square foot dimensions."She also went through a Cubist period, with bright, vivid colors- asymmetrical forms, geometrical forms, triangles," Ganjoula recalls. "As every artist goes through different stages in life and it shows in their work. The most recent are represented here- surrealistically looking back at yearspast and ahead to hopes remaining for the future. That's why you have cracked old trees and a house falling apart- sort of like the family life of a husband and wife and children who mature to go through their lot in life but, in the old house, there's still a strong foundation. It's a deeper philosophy and maybe a little bit darker."Of course, again, it's autobiographical, as is every artist's work,"

RAISSA LATYCH

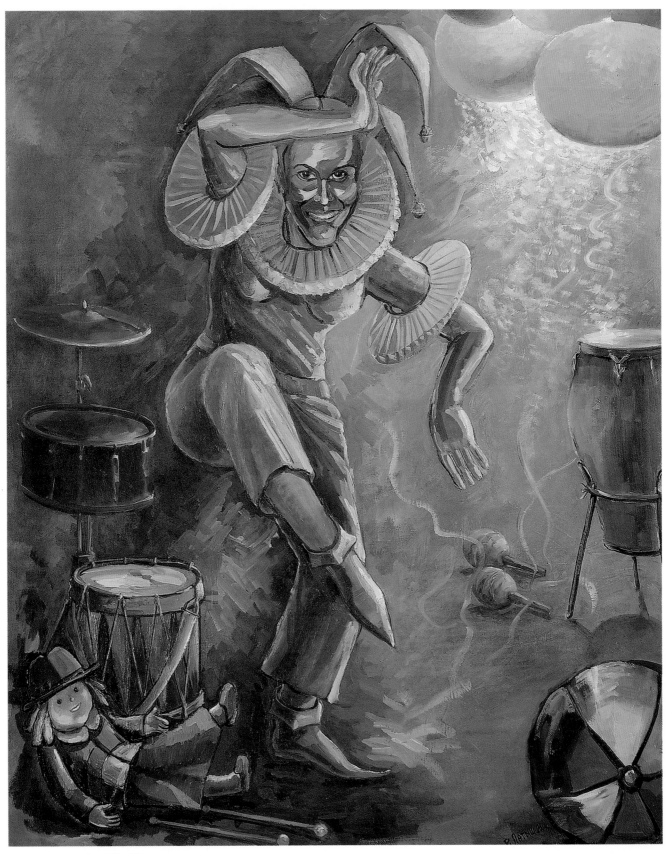

Celebration 40" x 32" Oil on canvas

RAISSA LATYCH

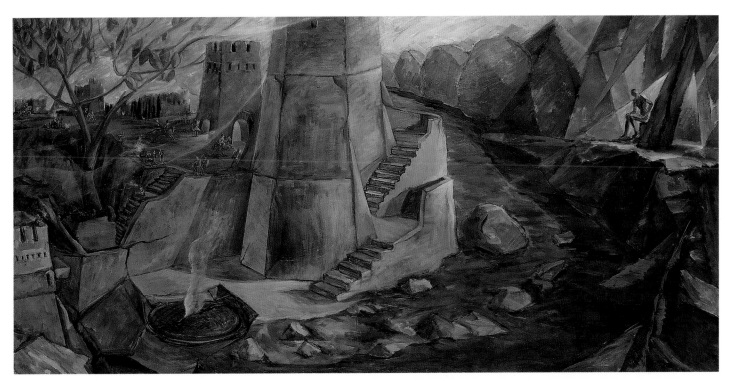

Pass Civilization 2004 37" x 75" Oil on canvas

Ganjoula continues. "It's about me and our separation. She lives in Russia most of the time and once every six months she comes here to America. We have a very strong relationship and that appears in her artwork- maybe, sometimes, as a theme of loneliness and, at the same time, the hope of better things." Ganjoula observes that her mother finds a wider philosophical freedom of expression in the United States in certain areas important to an active artist. She cites a stronger economy in the U.S., although it can be said that particular circles in Russia are thriving and although Moscow currently boasts no fewer than 27 billionaires as the oil and metal industries record exploding profits, according to Forbes magazine, the distribution of wealth finds its way into contemporary Russian art only at a level of about $10 million a year. While it should be noted that the contemporary art market has been coiling for an upward leap since the collapse of the Soviet Union, with a promise of dramatic impact upon that art scene, the general economic situation remains one of fairly common hardship. A daily struggle of living on the edge has displayed a pattern of spurring dynamic creativity in the individual artist in history and the economic turmoil of recent years has been paced by the unleashing of a Russian artistic community still in the process of discovering and building its way into new market realities that didn't exist in the former structure of governmentally delegated budgets for cultural activity.

Today, there are new channels opening; auction houses which had no place in the old system and, within the past few years, five world-class galleries which have already splashed their influence into other European capitals. "The people in Russia right now are more preoccupied with everyday life than themes like ecology, which occupy my mother's painting," Ganjoula notes. "It's a very intellectual country but, still, life demands are different there. There is still a focus upon big factories and producing, like the old five-year plan used to be, but it is encouraging now that there are some groups turning to environmental interests because they realize the reckless-ness of the path we're all on. "In Russia, if you look at the economical situation, there's either rich people or poor people- the middle class is not that strong," Ganjoula

observes. "In America, the middle is still pretty strong and that's why people are more open and receptive to any type of artistic expression. They buy according to what their tastes are; what their hearts tell them to buy. The Russian mindset has had this stan-dard of more traditional, Renaissance-type, academical, old time portraits, still lifes, landscapes and the like that has been popular and is still in demand. That's why it's harder to express yourself differently in Russia and artistic views like my mother's have a lesser response there. It's not because of any restrictions but because there are certain 'fashion' limitations."

Ganjoula finds a certain irony in a situation wherein artistic expression lags a bit behind political freedom; wherein the rigorous tradition of instruction and train-ing in classical techniques for the Russian artist remains not only an honored bench-mark for achievement in the arts but also a largely closed framework for exploration. "It is easier to be creative there at this time, I think, yes," she believes. "Those times- the Stalin period; the Breshnev period; when everything revolved around politics and the government would dictate which artwork should be published or how artists should paint...those times are gone, thank God. Now, it's pretty much the same as here in America- freedom of expression, freedom of speech...but America supports emerging artists even better than Europe. In Russia, if you want to be successful, you need to be a realistic artist painting pictures of famous people, celebrities or politicians, to sup-port yourself. Here, in America, people are more receptive to an artist's vision of any-thing. So, even with this political freedom and democracy, this tradition still holds artists within certain frames to find success."

Exhibited in Russia and numerous European cities, Latych's work, since 1998, has also appeared in the museums and galleries of California. Her paintings retain a flare of folk sensibility cast before an international eye and, by drawing us in to discern the subtle environmental and ecological conditions related to the human circum-stance, reminds us that imagination finds its springboard in reality.

-G. Alexander Irving

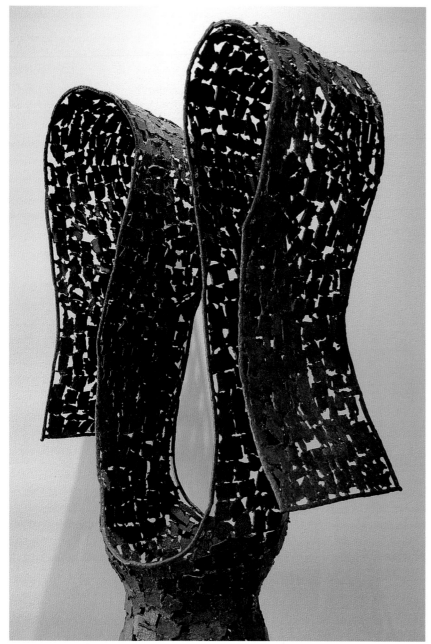

Warren Vase (detail) 57" x 38" x 14" Bronze sculpture

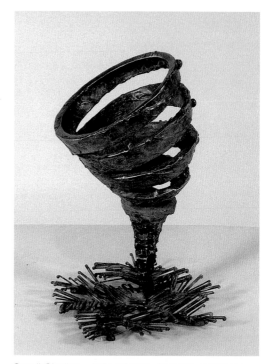

Small Chalice 10" x 7" x 7" Bronze sculpture

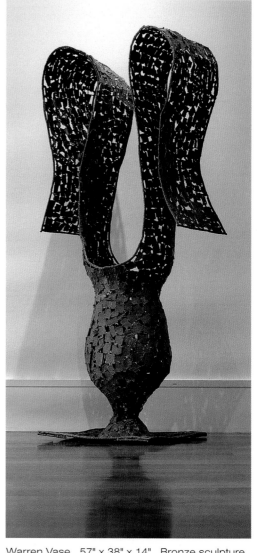

Warren Vase 57" x 38" x 14" Bronze sculpture

JAMES A. DIXON

A native of Texas who grew up in Colorado, James Dixon studied art after high school with the post abstract expressionist painter David L. Dietemann. He was an apprentice for sculptors Ed Dwight and Raymond B. Fedde. He earned a B.F.A. and an M.F.A. at Colorado State University, and then worked with the late Andy Warhol, the Mnemonist Orchestra and jazz artist Hugh Ragin. For the past decade, he has focused on bronze art casting.

James Dixon recently created an interior bronze fountain as his first public art project. One of his wall pieces is included in the exhibit catalogue for the national tour, "The Spirit of Martin." His artwork is featured in the private collections of the Reverend Jesse Jackson, the Black American West Museum, and music composers Valerie Ashford and Nick Simpson.

I draw inspiration for my bronze sculpture from the cast-offs, leftovers and by-products of the ordinary foundry processes. The slurry purges, sprueing systems and casting mis-runs start my juices flowing.

Geo-Abstraction II, London 160 cm x 162 cm Mixed media on canvas

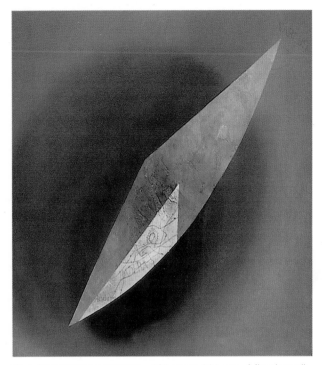

Geo-Abstraction II, Hadera 125 cm x 111 cm Mixed media

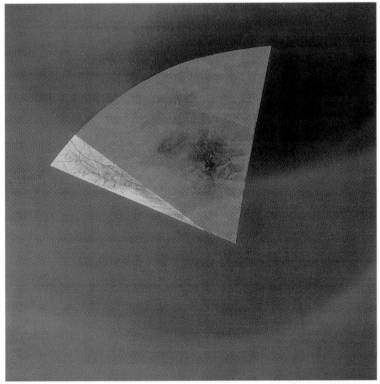

Geo-Abstraction II, Amman 160 cm x 162 cm Mixed media on canvas

ROSA KIM PAIK

Rosa Paik received a B.F.A. from Kyung Hee University in Seoul, Korea, and an M.F.A. from the Pennsylvania Academy of the Fine Arts in Philadelphia, Pa. She also gained experience at Studio Art Centers International, Florence, Italy. Sha has had solo exhibitions at Gallery Space Haam and Gallery Wooduck in Seoul, and at the Pennsylvania Academy, and has participated in numerous group shows.

Through a detached image, I depict the relationship between nature and human activity. Symbolized by maps and spatial landscape, my paintings involve a simplified view of nature and a map as a dialectic way of dealing with subject matter. Maps offer a way of expressing my interest in the emergence of terrorism and urban violence in today's belligerent world.

Pennypacker 22 ¾" x 18" Acrylic

Homily 20 ¼" x 17" Acrylic

PETER A. MENSER

A native of Los Angeles, California, Peter Alan Menser received a B.F.A. in painting from California State University in Long Beach. He was inspired by the Abstract Expressionists of the 1940s and 1950s and by the Bay Area Painters of the 1950's and 1960s. Menser has also lived and worked in Hawaii, the Florida Keys, and currently in Houston, Texas.

'Doing Art' is a complex and personal process, which is sometimes successful, sometimes not, but it's always an interesting journey. My paintings, to me, are never finished. They seem to be in a state of flux, always unsettled.

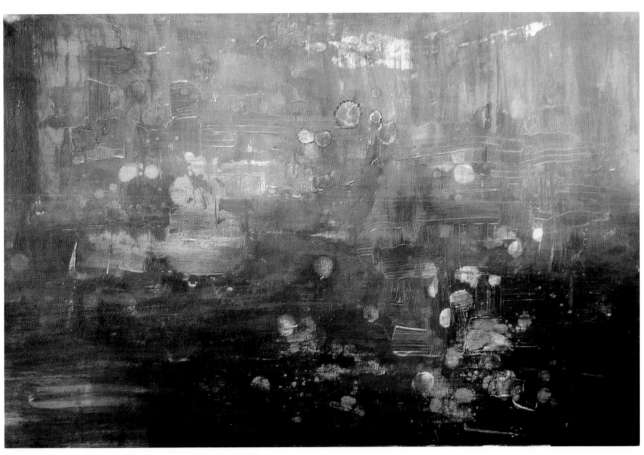

Monet 2006 20" x 30" Mixed media on board

Encaustic Blue 24" x 24" Encaustic

Rothko in Magenta 30" x 30" Mixed media with oil & wax

PATRICIA SEGGEBRUCH

Patricia Seggebruch began her artistic career in the folk art tradition of floor cloth painting. During the past 9 years, she has taught herself to draw and paint, using watercolor, acrylic and ink. Her work has appeared in exhibits in central Michiganas well as Seattle, Washington.

The artist won the Experimental Award at the California Watercolor Society's exhibit in San Francisco. Her work has been shown at the National Watercolor Society's Side by Side Show in San Pedro, California, and at Allied Artists of America in New York City. She conducts demonstrations for Daniel Smith Art Supply in Seattle, Washington and teaches through her studio in Snonmsish, WA.

Inspiration for my work does not come from things external. I rarely explore vast landscapes or conduct intimate character studied, but rather work from the inside out. My paintings explore internal self-discovery through the emotional response to color and texture.

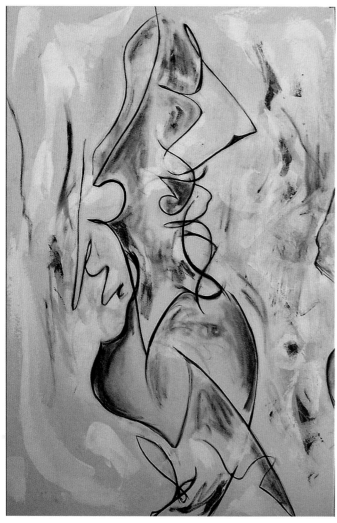

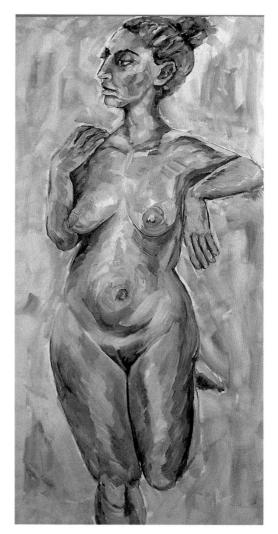

The Lady is a Tramp 36" x 24" Charcoal, gesso and iron oxide
on canvas

Madame X 48" x 24" Acrylic on wood

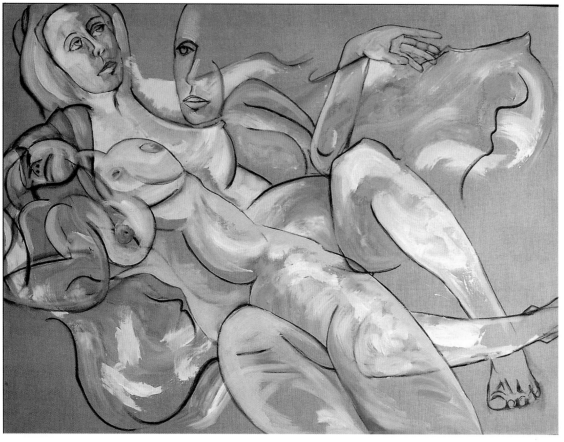

Fickle Lady 36" x 48" Acrylic

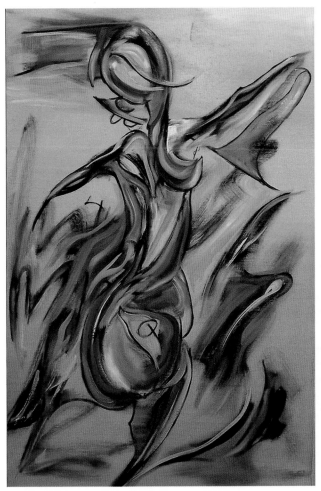

Fire Dancer 36" x 24" Oil on linen

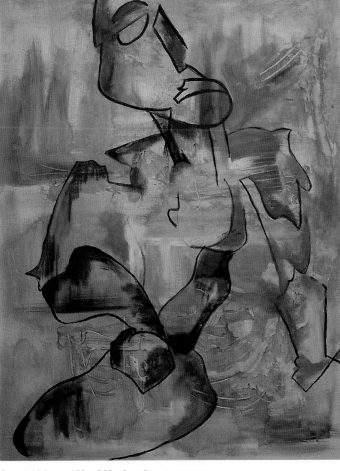

Steroid Man 40" x 30" Acrylic on canvas

ROBERT WEIR

The artist was an only child reared by working class parents, whose sole ambition was to put their son through college. The family lived near the factories associated with the then-booming automobile industry in Detroit, Michigan, where his mother operated a small truck stop luncheonette. Her customers ranged from beer truck drivers to bank presidents with a few mobsters thrown in. Observing these characters, Robert Weir developed an early interest in human nature and art of the human form.

After retiring from a career as a design engineer, administrator and manager of a major oil company, the artist retired to pursue his interest in art. He studied at the Art Students League in New York City; The Art League in Houston, Texas, and The Glassell School of Art also in Houston. His work has been exhibited since 2001.

The purpose of art is to help us communicate with our unconscious. The face touches the elemental source of thought. One expression captures more feelings than could be covered in many pages of the written word. My portrait work is almost always taken from the live model. There is magic that occurs when painting from life. Beyond likeness, these paintings can capture the inner person.

RICHARD PANTELL

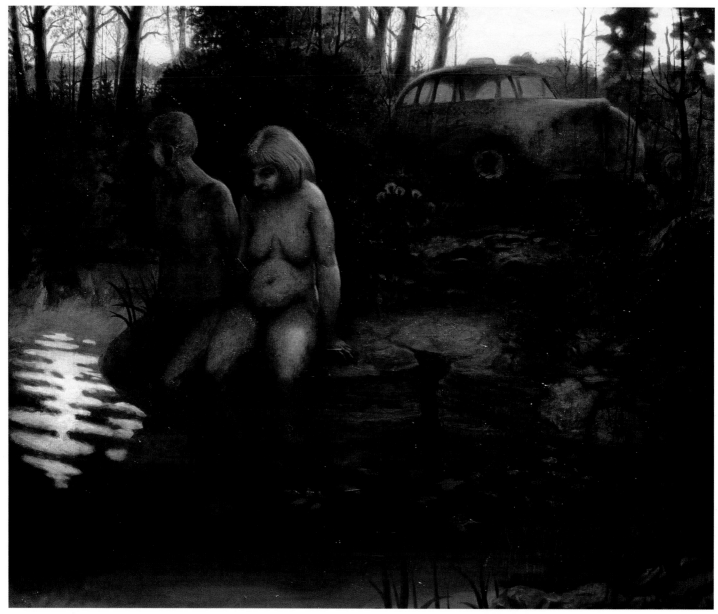

Couple 53" x 62" Oil on canvas

KAREN WHITMAN AND RICHARD PANTELL

Although they may not have an "I Love N.Y." sticker on their bumpers, their affection for their home state and for its greatest city, in particular, is readily evident in the work of Richard Pantell and Karen Whitman. While the cityscape can be a cool, detached appreciation of architectural splendor or squalor in the hands of many artists or even alienated enmity in the eyes of some, there seems to be a humanizing familiarity even in the "de-peopled" scenes of New York offered in the award-winning paintings and hand-carved prints issuing from this creative pair.

Born in the Bronx and raised from her earliest years in a Long Island suburb, Karen followed her childhood enthusiasms for art through a degree in printmaking from Buffalo SUNY and further study at the Parsons School of Design and the Art Students League of New York while residing in Manhattan in subsequent years.

Having first met Pantell in a landscape painting class at the Woodstock School of Art in 1991, while she was busy falling in love with the atmosphere of the upstate artist colony, Karen recognized him as an instructor at the school when they met again at an art auction the following year.

Also born in the Bronx, Richard (or Rick, as he is more commonly known) had moved upstate to Ossning with his parents before heading off to study at the University of Bridgeport (Connecticut) and, afterwards, a youth-fueled wandering of the country from Martha's Vineyard to the wilds of Idaho. It was while playing guitar out west and trying to decide between a career in music or art that Pantell opted to return to New York and study at the Art Students League. Eventually, after a couple of years of living in Sweden, he discovered Woodstock through its art school and settled in.

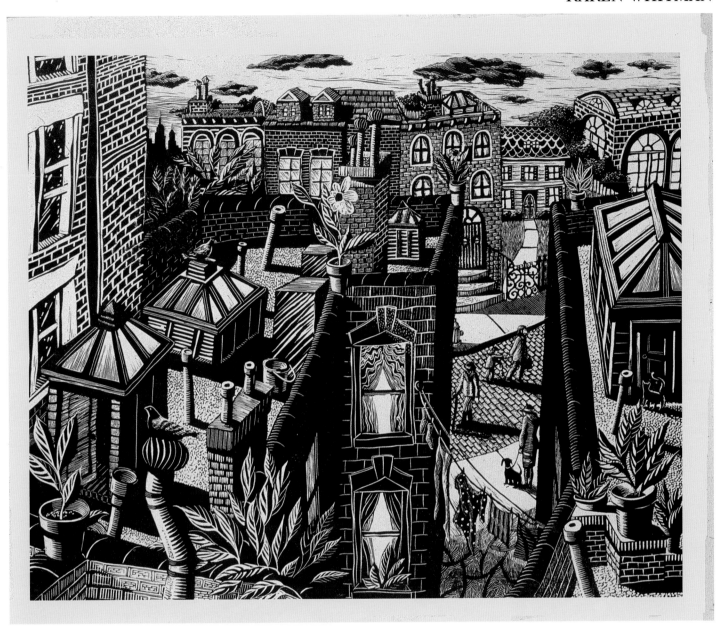

Village Morning 17" x 21" Linocut

Whitman also had her musical interludes before Woodstock, including a stint as lead singer in a popular folk group called The Balkanizers, all of which happened prior to her discovery of the linocut block printing techniques which illuminate her work today. The process involves multi-block carvings which are then fitted to an old Vandercook press for one-color-at-a-time print making.

"This is a wonderful press," Whitman beams. "The generic name for it is a 'horizontal proof press'– made to proof metal type before we went to higher speed presses... It makes it possible for me to do really complex work with beautiful registration like this..." she said, indicating an enchanting six-block print which was featured in *American Artist* magazine in 2002.

Although she had studied printmaking, etching and lithography at Buffalo State University, block printing had not been part of the curriculum at that time and chancing into the early 20th Century

press opened new and fresh horizons to the artist.

"I love working with light and dark and pattern and texture; sometimes I think of my work as being almost like a quilt, juxtaposing all different kinds of textures," Whitman smiles bemusedly. "I've always loved the cityscape and blockprinting has a special affinity for the city because it's such a graphic kind of medium– very good for making crisp edges and angles. There's no limit to how many windows I'm willing to do. Detail doesn't scare me. In fact, the more detail there is, the more attracted I am to it."

Pantell grins an indication that he's less inclined to "do windows" lately, confessing that he once counted over 600 windows in one of his cityscape paintings. His latest work has been featuring more interior scenes, touched with the lightly whimsical quality that clings to the work of both artists.

continued on page 44

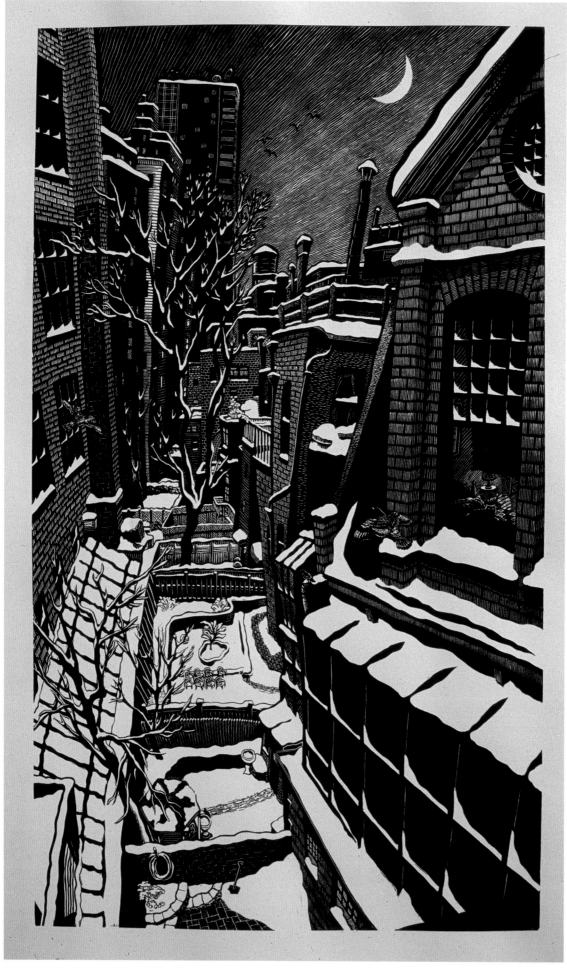

Backyards in Winter 36" x 20⁵/₈" Linoleum cut

KAREN WHITMAN

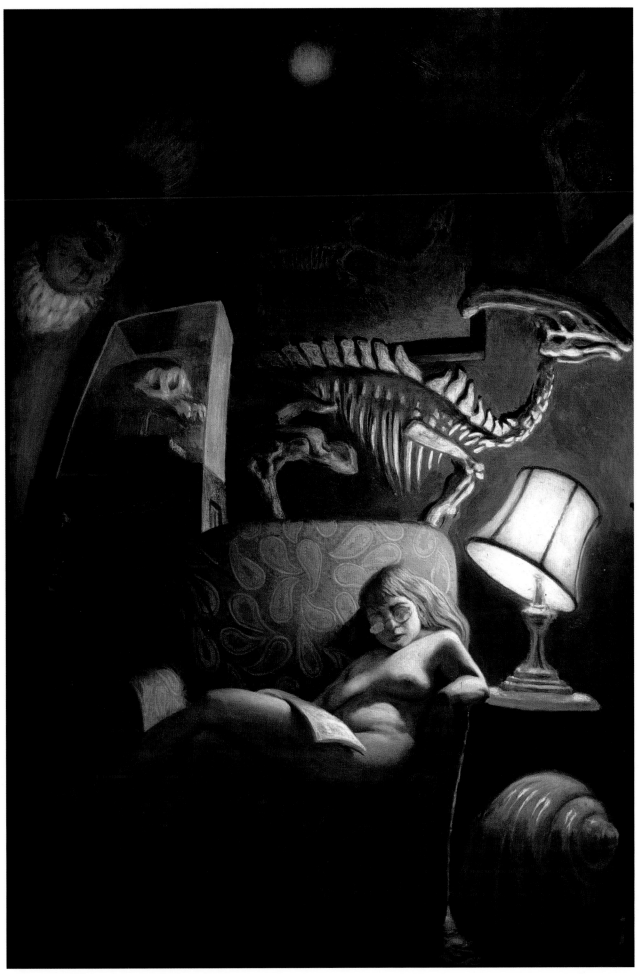

Sleeping Paleontologist 36" x 24" Oil on canvas

RICHARD PANTELL

RICHARD PANTELL

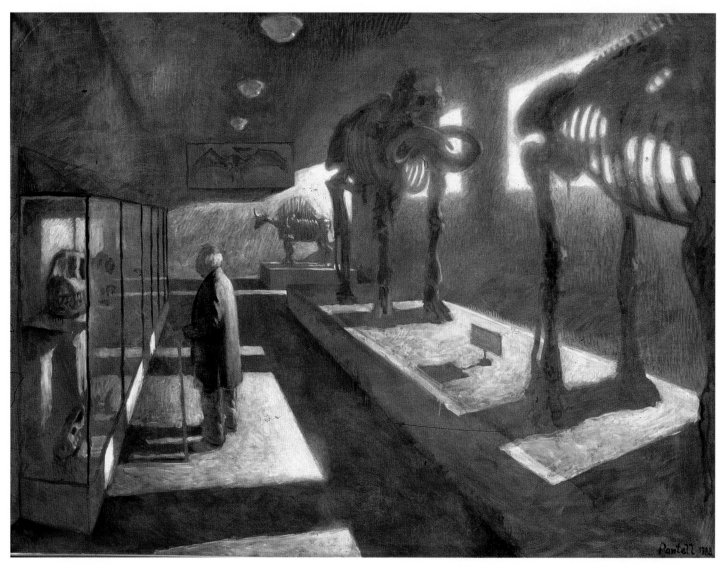

Not of This Time 56" x 76" Oil on canvas

"I've just been zooming in on people, individuals, recently," Pantell explained. "I've always gone back and forth with that but now, more than ever, I've been focusing on character rather than panoramic views, which I've done for 30 years. I think it was the windows that were getting to me," he laughs.

Neither artist sees any problem with shifting buildings around in their composition. Pantell has another grin for the life-long New Yorkers he overheard, as they stood before one of his paintings at an exhibition, arguing whether a building he has moved in the background of the scene should be over there or over there.

"That's one thing about doing New York imagery– or any specific town– where the scene is totally rearranged," Pantell grinned mischievously. "People in New York *have* to know– 'Well, where is this? What corner is that?' They have a *need* to know which subway station is it where both the #2 and #3 trains are going in the

same direction on the same platform instead of opposite directions. This stuff comes up all the time. But I always move a few buildings around. Karen does it, too."

"I find that when I make my imagery, some of it I do on location and I'll literally take basically all the elements I see but maybe change the perspective of it," Karen added. "Even on the spot, I'll be changing as I draw it. Other times, I'll take something on location and add elements from imagination once I leave. Then there are other times when I'll make up the entire thing, like this one," she gestures to a New York scene on the wall. "Except that when I decided it looked like a downtown street, I put in the Brooklyn Bridge in the upper left hand corner just to cement the idea that it was downtown."

A Pantell painting which won a Medal of Honor from Allied Artists of America last year sports an unusual view of the

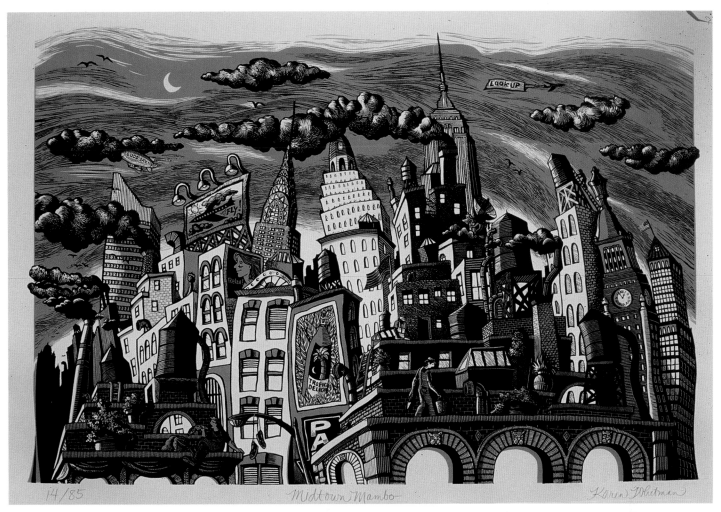

Midtown Mambo 24" x 36¾" Linoleum cut

Williamsburgh Bridge in Brooklyn which came from a sketch he did from the window of Whitman's workplace on her last day of employment there.

"I worked for years as a color separator for a fine arts silkscreen company," Whitman notes. "We would get original contemporary paintings by living artists and I would handpaint color separations and make silkscreen reproductions of them. I would basically look at a painting on an easel in front of me and take treated acetates and paint out sections to photographically make a silkscreen from what I did. I had to have a very clear idea in my head of what color ink they were going to print that screen with as I was making my imagery and just how opaque, transparent or in-between that shade should be as well as the strategy of which color goes over which and where in the sequence they'd be printed in– which was usually somewhere between 50 and 75 colors. You could take six weeks to do some of these images, so it gave me all the training I needed to do my own little 10-color prints from hand-carved blocks."

Like the view of the bridge from Karen's work bench, most of Rick's images find their origin in pencil sketches.

"Sometimes from life but very often not," he says. "I make them up or distort them. There's a lot of that." Like the elderly couple depicted in these pages, Pantell explains, which evolved from a series of sketches, variations on a theme, over a period of some 15 years before they settled into place upon their canvas.

"I've got tons of drawings going back 25, 30 years and I'm still working on ideas from those. Some I started decades ago and I'm just getting to them now," he reveals. "But, if something just grabs me, I'll do it right away."

A recent print by Whitman reveals a warming logic beyond mere artistic adjustments of visual balance in her work. Depicting a backyard view out of an urban apartment, the scene presents a composition one immediately senses as less severe than the harsh architectural angles you would expect from such a perspective.

continued on page 49

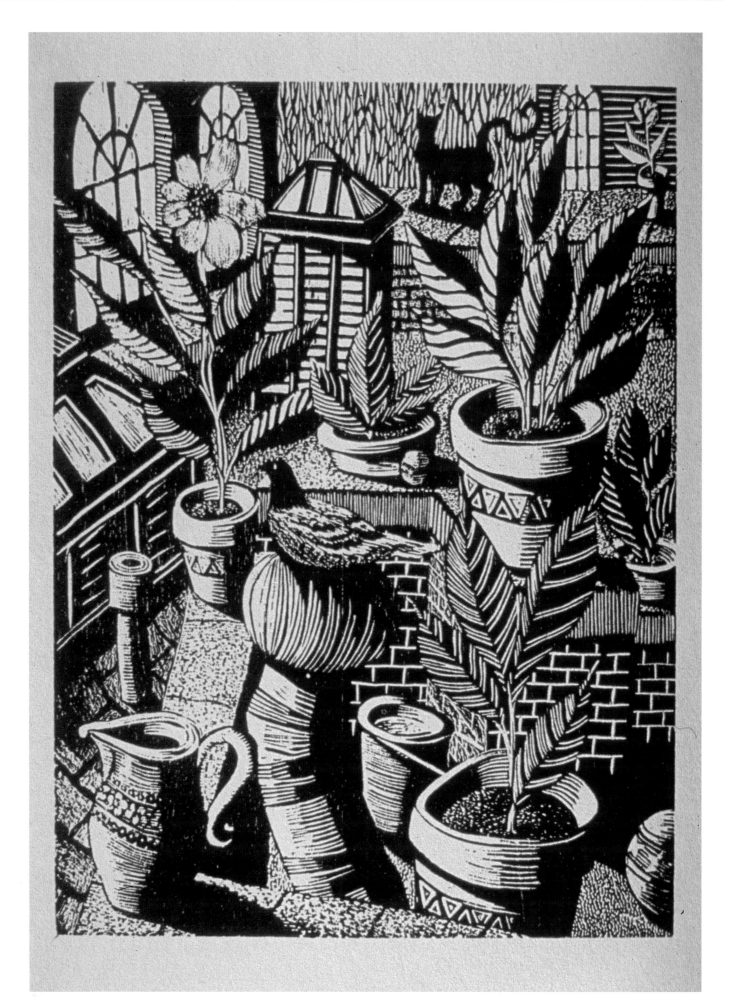

Rooftop Garden 8" x 6" Woodcut

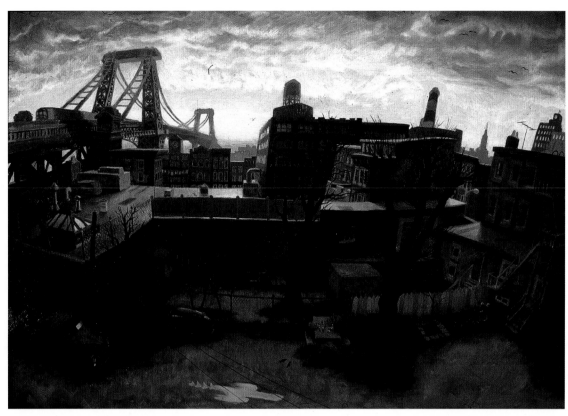

Backyards 24" x 36" Oil on canvas

Blue Sue 50" x 58" Oil on canvas

Fantasia on Brooklyn 35⅝" x 23" Linoleum cut

And the Sea Was Parted Once More... 36" x 40" Oil
Dedication to Raoul Wallenberg

Lines have been tilted a touch, softened, coaxed into kinder, friendlier angles– humanized, so to speak. Textures are adjusted, parallels bent ever so slightly to effect the overall atmosphere.

Remark that Pantell's paintings and her own printmaking share a trade-off between fantasy and reality and she embraces the observation; "Yes, and I think our work goes really well together when we do show at the same time because we have a similar sensibility about a lot of things."

With artistic styles compatible enough to be strikingly intercomplimentary in dual exhibition while maintaining distinctive individualities of viewpoint, the husband and wife team blend even more seamlessly in the musical sphere as folkstylists Whitman and Pantell. As their variously moving and amusing 2006 cd release *Chicken Fat Pudding and Other Delights* amply demonstrates, their artistic virtuosity extends well beyond visual realms. [Available from CDBaby.com or whitmanandpantell.com]. More of their artwork can be viewed at BearsvilleGraphics.com

—*G. Alexander Irving*

For My Friend 17" x 24" Monotype

Essence 17" x 24" Monotype

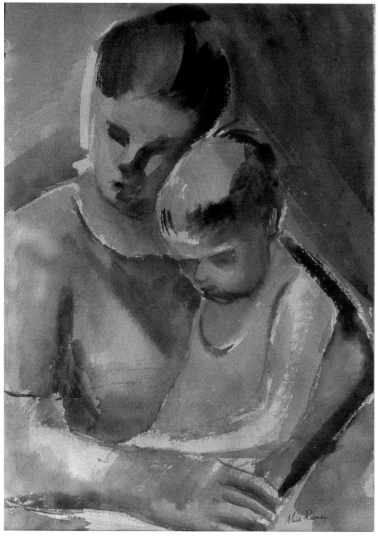

Mother & Child 24" x 19" Watercolor

ALISSA GOLDRING

Alissa Goldring began life in lower Manhattan, but her earliest treasured memories are of a North Carolina farm. Her family's return to New York City devastated her, and art became her life-line. After earning a M.A. degree from Columbia University, Goldring taught art. She moved with her children to Mexico in 1954 and worked as a photographer.

Her work was exhibited in solo shows in Mexico City, Guadalajara, and throughout the country. She practiced meditation in India, and settled in California, where she taught "Dreamplay" and created art. Her photographs are archived by the University of California at Santa Cruz. Recently, she received the Pajaro Valley Visual Arts Award and Graphics Art Award.

One of my favorite quotes is Robert Henri's: 'Art may not earn you a living, but it will make you a life.

Springtime Glance 15" x 20" Pen, ink, watercolor, gouache

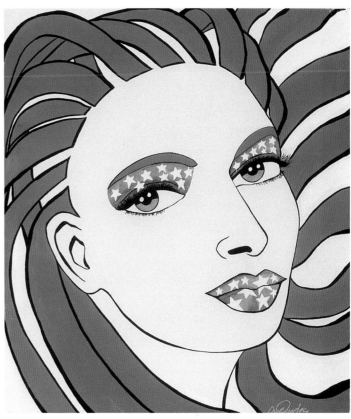

American Beauty 11" x 14" Pen, ink, watercolor, gouache

Autumn Thoughts 15" x 20" Pen, ink, watercolor, gouache

OSCAR QUARLES

With a B.F.A. in Cartooning Illustration from the School of Visual Arts in New York City, Oscar Quarles is a hands-on commercial artist who has developed his own signature techniques and style. Freelance jewelry and logo design, book and fashion illustration are among his creative endeavors. He was Assistant Head Production Artist for Outwear Magazine, a designer for Fanta-Eyes and Bling-Bling, Inc., and an illustrator for Erickson & Basloe Advertising L.T.D., all in New York City.

I'm influenced by Patrick Nagel, "Anime" (Japanese animation), graphic design, and whatever else I see.

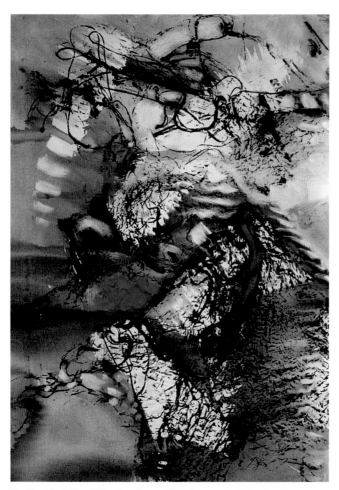

Untitled I 24" x 30" Acrylic on Canvas

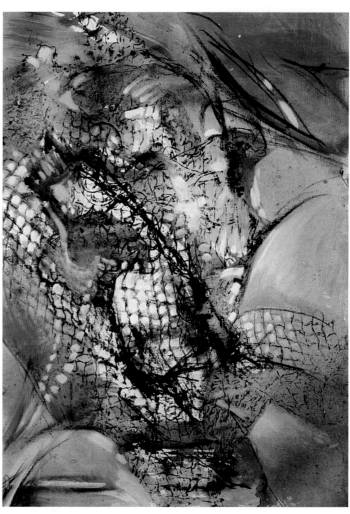

Untitled IV 24" x 30" Acrylic on Canvas

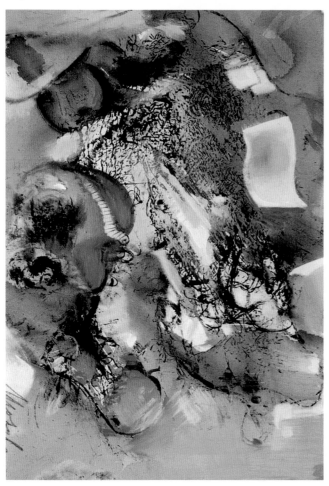

Untitled III 24" x 30" Acrylic on Canvas

VIOLA MOTYL-PALFFY

Born in Sobrance, Slovakia, Viola Motyl-Palffy is a painter whose work represents her native country. After earning a degree in Fine Art from the University P.J. Sfarik in Presov, Slovakia, she became a member of the Visarte Artists Group of Zurich and has participated in various exhibitions throughout Europe, USA and in Osaka, Japan.

The President of the Slovak Republic, Rudolf Schuster, invited her in 2002 to have a month-long solo exhibition in the Slovakian White House. This distinction was followed in 2005 when the Slovak Minister of Foreign Affairs, Dr. Eduard Kukan, awarded Mrs. Motyl-Palffy the Gold Medal for Life Achievement for representing Slovak arts and culture abroad.

We artists must paint what we love and do it the way we want to do it. Then we will love what we paint, and we will surely find an observer who loves our work, too.

Untitled II 24" x 30" Acrylic on Canvas

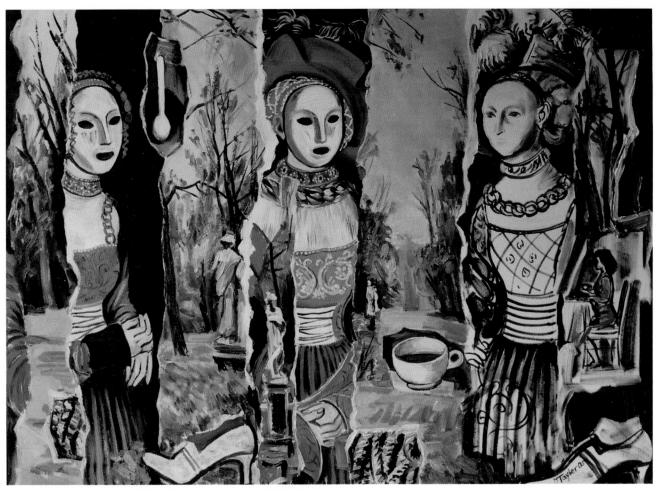

Three Girls　32" x 44"　Oil, mixed media on canvas

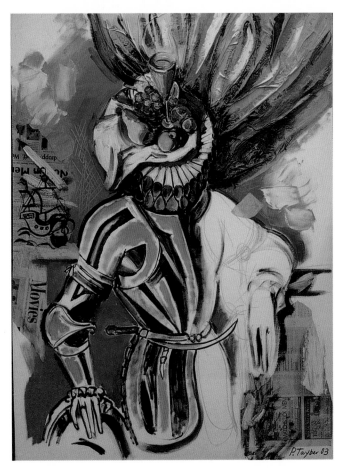

The Unfinished Parade Portrait　40" x 30"　Oil, mixed media

PAVEL TAYBER

Ukrainian art historical texts recognize Pavel Tayber as an outstanding contemporary artist. He was born in Kharkov in 1940 and grew up to become a member of the Union of the Artists of the Ukraine and an Honored Artist in 1992.

The painter has resided in Palo Alto, California since 1995, and shows his art in galleries there and in New York City and San Francisco. Numerous museums, fine art galleries and individuals in the Canada, Germany, Sweden, Israel, Great Britain, France, Spain and Russia as well as the U.S.A. and Ukraine have acquired Tayber's works.

One absurd goal the critic sets before himself is to place the artist into some kind of rubric—'impressionistic,' 'romantic,' 'historical,' 'realist,' 'visionary,' 'cubist,'—and thus compare the artist to others. I slip out of such a classification. I am an elemental post-modernist, a combination of spontaneous and explosive artistic temperament with cultural intellect.

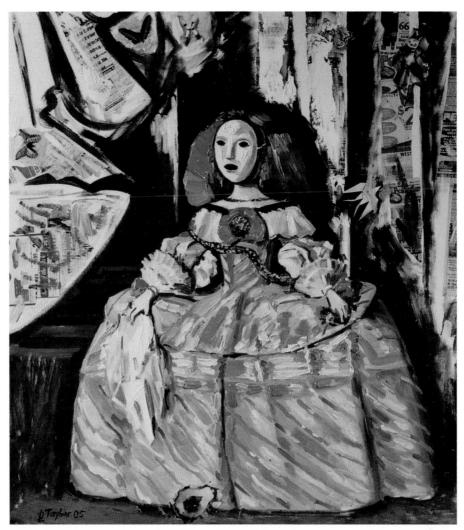

Margarita 36" x 33" Oil, mixed media on canvas

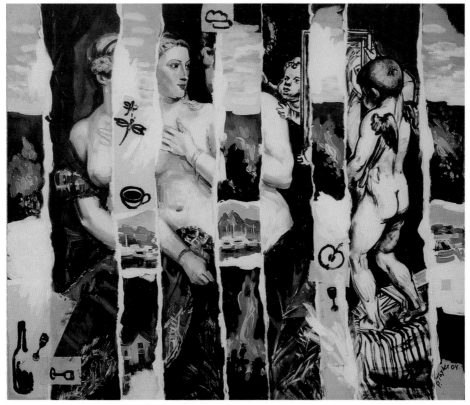

The Broken Mirror 40" x 48" Oil, mixed media on canvas

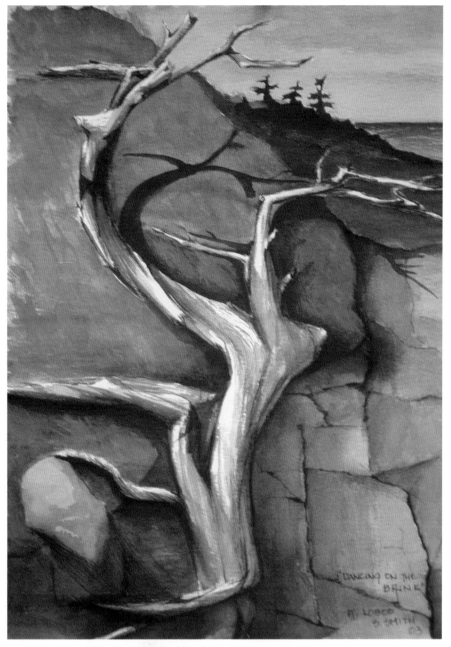

Dancing on the Brink of the World 8.5" x 20" Watercolor

SARAH (SALLY) GIDDINGS SMITH

Sally Smith grew up in Maine, influenced by the artists John Marin, Vincent Hartgen and Marsden Hartley. As a student at Wellesley College, she was apprenticed to the sculptor, Sigmund Abeles, and was one of the first women to paint for academic credit. She has designed and built houses, restored old houses, and illustrated books.

Now working in Paris, her art has been exhibited at the Carl Cherry Center in Carmel and the Avery Gallery in Seaside, California; the Pacific Grove Art Center; and the Slowart Gallery in Chelsea, New York City. Her work is valued by collectors in California, Maine, Vermont, Massachusetts, Montreal, Washington, D.C., Florida, as well as Paris.

I paint the land, trees, rocks, the sea, because they provide me refuge, solace from the antics of humanity. In painting people, I find some distance from the immediate presence of the person, and paint whatever my hands see."

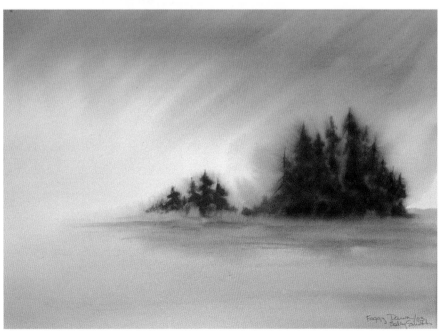

Foggy Dawn 14" x 20" Watercolor

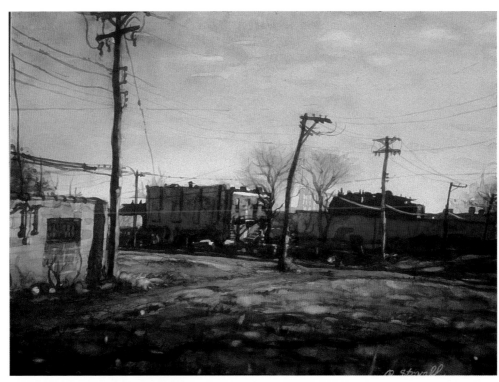

Former Glory 20" x 17" Watercolor

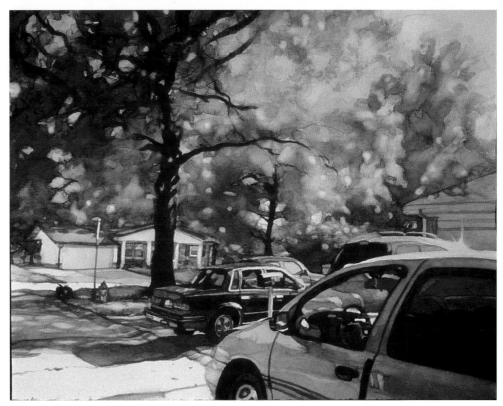

The Neighborhood 21" x 18" Watercolor

RODNEY STOVALL

Missouri-based artist Rodney Stovall received his training at the Forest Park Community College, where he studied commercial art, lettering and layout, design, figure anatomy and advanced drawing. In 1992, he studied advertising layout and production, color theory and lettering at Florissant Valley Community College. He was a lecturer for Voices at Clayton Schools, sponsored by Art St. Louis, where his work has been exhibited. He has attended demonstrations and practice sessions for children in Brittany Woods School, University City, Mo., and has shown his water colors at University City Commerce Bank.

I feel so much joy in painting, it's probably the same kind of joy God Had when he created us.

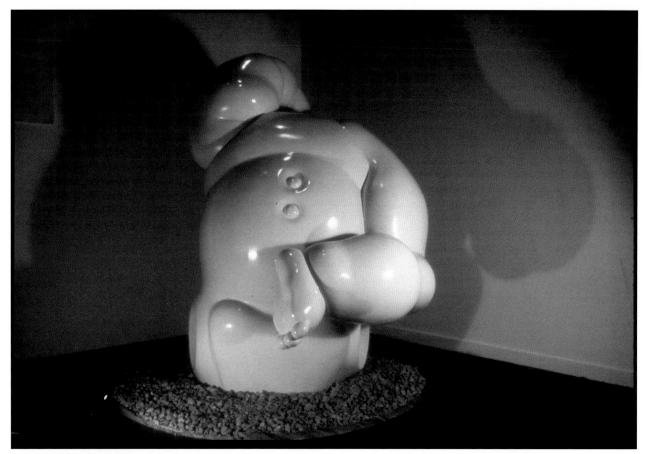

Self Portrait: Baby Doll 7' x 4' x 4' Fiberglass

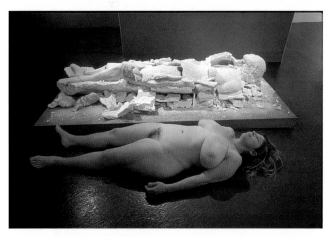

Art Life 1' x 6' x 6' Glass figure, human figure; with L.R. Altman

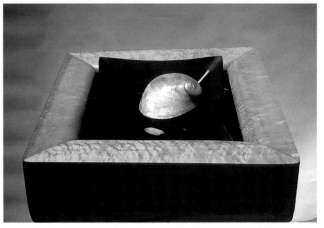

Real Sculptor 31" x 20" x 20" Birdseye maple wood, shells, water

ALISON ULMAN

Alison Ulman sees with her hands and feet, perhaps an artistic advantage to the visually impaired sculptor, whose conceptual pieces are progressive and exquisitely executed by any standard. Born in Oakland, California, in 1955, Ulman earned a B.A. with Honors in Fine Art from the University of California at Santa Cruz. She was named Artist in Residence at the Palace of the Legion of Honor in San Francisco in 2003, Outstanding Artist at "Insights 2003" at City Hall in San Francisco, Best of Open Studio Tour, San Francisco, and numerous other awards

A solo exhibit, *EndlessProcess.com-An in-depth exploration of the artistic process on the World-wide Web*, was presented in Oakland in 2001. Her work has been exhibited at Visual Art Access in San Francisco and Bridge Gallery in Santa Cruz, and among numerous major group exhibitions.

Being blind helps me stay awake and alive on the cusp of danger, moving boldly through the unrealized hazards of the world as threats spring out of hidden coverts and snares appear before my feet. Powerful tools and powerful chemicals keep me on my toes. I'm into the moment, the power and freedom of the moment, and physical risk adds wings to my feet!

A Loving Self 42" x 8½" x 8½" Glass, porcelain, water

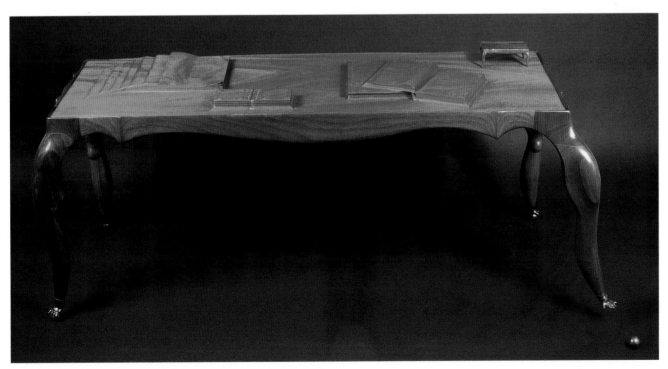

A Coffeetable is Work 29" x 72" x 27" Mahogany wood, bronze

The Five Horsemen 52" x 24" Engraved leather

The White Tiger 36" x 24" Engraved leather

LAWRENCE RALSTON HUGO

Lawrence Ralston Hugo grew up in rural Pennsylvania,
influenced by his father's knowledge as a sociology professor.
After graduating from Duquesne University, Lawrence Hugo
moved to the mountains of Southern Oregon, where he resides
today. In this secluded environment, he creates series of
murals dealing with archetypal symbols and images. He
learned leather crafting as a child and incorporates that
medium in his work. He is a self-taught artist.

*I bring a sense of unity to mankind through an effort to
translate the symbols and archetypes that are swirling in
the universe of humanity. There are many questions
raised. Love is the answer.*

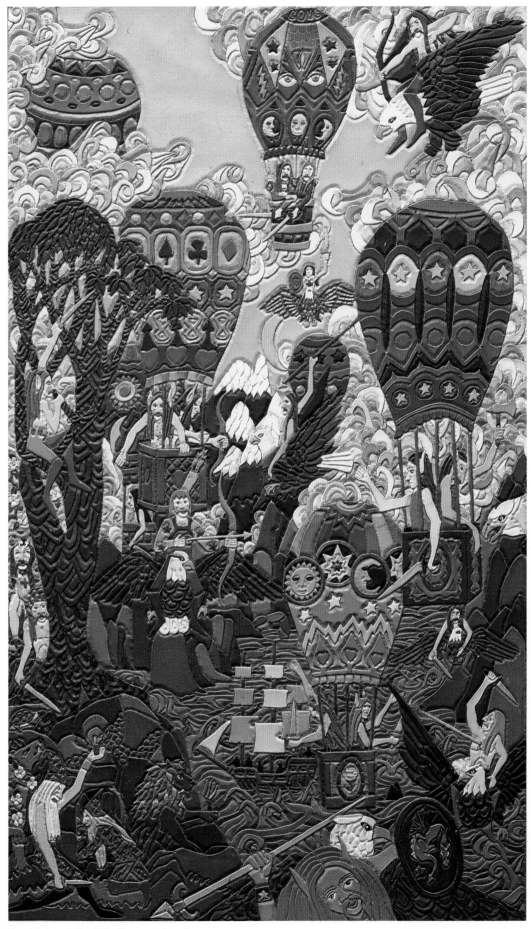

Dog Fight 35" x 22" Engraved leather

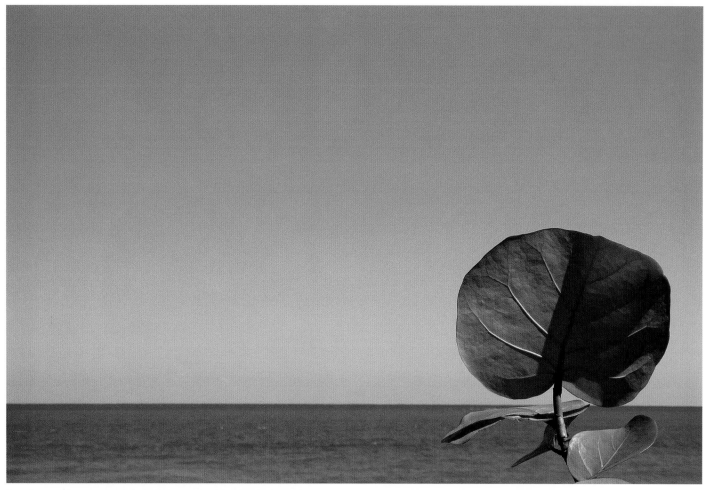

Sea Grape One 20" x 24" Photography, chromogenic print

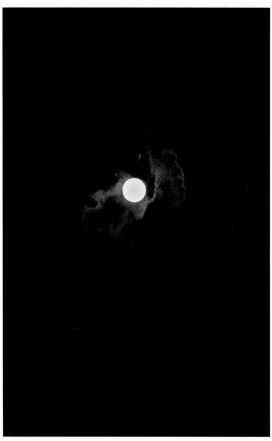

SANDRA GOTTLIEB

Educated at the International Center of Photography and the New York School of Interior Design, both in New York City, this urbane photographer's work is widely exhibited and appreciated. Her images have been used in the study of Art and the Humanities at the University level since 1996. She is affiliated with the National Association of Women Artists, Professional Women Photographers, the Palm Beach Photographic Centre, and other notable groups.

Sandra Gottlieb's work is in the collections of Senator Charles Schumer of New York, the Ellen and Richard Sandor Family Collection of Vintage and Contemporary Photographs, and others.

Represented by World Fine Art Gallery, she has shown her photographs recently at the New York Museum of Water, the Hilton Head Art League in South Carolina, and the Barrett Art Center in Poughkeepsie, N.Y.

With a sensibility to the specificity of light, the camera can push the limits of the tension between real and abstract to create a balance of sculptural form and natural sensuality.

Full Moon 30" x 20" Photography, chromogenic print

Orange and Yellow #2 20" x 30" Photography, chromogenic print

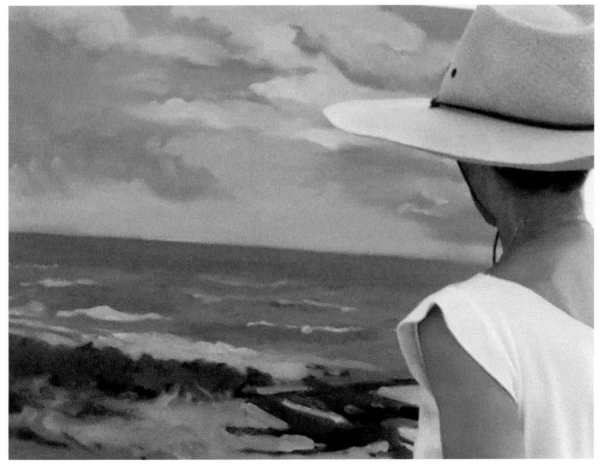

Artist's View 20" x 24" Photography, chromogenic print

Full Moon Fire 32" x 32" Acrylic on canvas

Event & Explanation 24" x 30" Acrylic on arches

SILJA TALIKKA LAHTINEN

All the World is Green 24" x 24" Acrylic on canvas

Silja Talikka Lahtinen draws from the myths, landscape, folk songs and textiles of her native Finland. Her mystical artwork is informed by Lapland Shamanism. She earned a Bachelor's and Master's Degrees from Helsinki University.

The State of Georgia Award for Women in the Visual Arts was presented to her in 1997. She is included in Who's Who in American Art 1995-1996, Print World Directory 1998, and Strathmore's Who's Who 1998. Her work is exhibited across the U.S., Finland and France. Recent shows include a solo exhibit in July 2006 in Ruovesi, Finland; Kennesaw College and Elevations Gallery, Atlanta in 2003, and at the Ward-Nasse Gallery in New York City, 2003-2004.

All I ever wanted was to create the best painting. My instrument is myself and my style is what I am.

Upon Waking 32" x 40" Acrylic on canvas

No Birds 24" x 36" Acrylic and mixed media on cut canvas

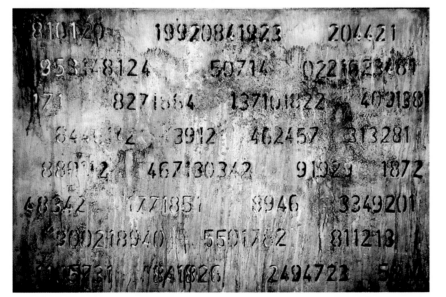

Safely Fluttering in the Backward North 40" x 60" Acrylic & mixed media on canvas

JEFFREY DEAN WINKLER

Jeffrey Dean Winkler's formal arts education resulted in several awards at statewide student exhibitions. After focusing his efforts on music for years, he recently turned to painting as his primary means of expression.

In that short time, he has had a solo exhibit, "The Green Ant," and participated in a group show, "Beyond Ordinary," both in Salt Lake City, Utah in 2005. In 2001, Winkler produced a 30 minute video presentation, "Smoking Gun," with live musical accompaniment.

Art is the process by which the soul establishes itself as a 'fact' outside the physical self, a fact which may ultimately be regarded or discarded, but that is indisputable nonetheless. This aspect of art is a great comfort to the soul in a world that is becoming increasingly 'irreal' and illusory by the day.

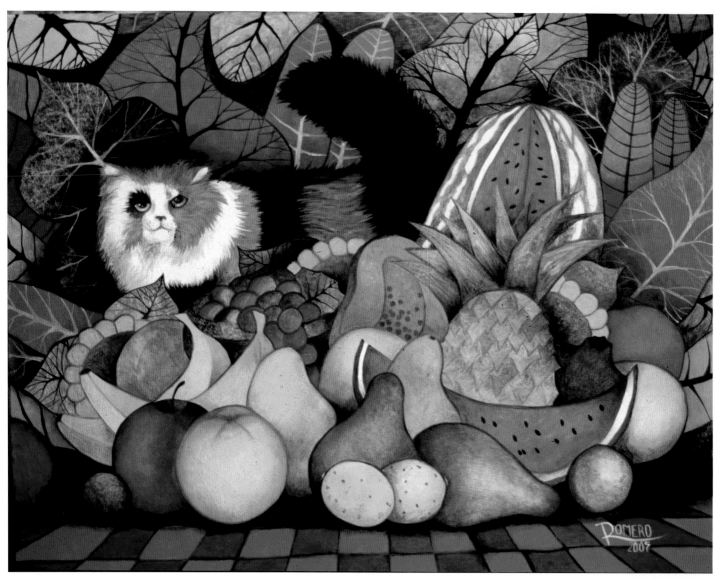

The Cat 30" x 24" Oil

FRANCISCO ROMERO

There's a charm-enchanted glow in the paintings of Francisco Romero that blends a fresh, raw vibrancy of tone with a disarming simplicity of warmly humored vision. Using a vivid and universal language of color spoken in his own personal dialect, he conveys an autobiographical expression of his experiences of life and finds self-revelation beyond measurable borders.

 Born in Juarez, Mexico in 1958, Romero began learning the appeal of sketched forms in his first decade of life by studying and emulating figures presented in cartoons and comic books. Drawn increasingly into visual arts during his high school years, he went on to earn a degree in interior and graphic design from the University of Juarez.

 It was his migration to the United States that Romero credits with a 180 degree change in the opportunities afforded to his eloquent talents of naturing a scene with emotional influence. The festive cultural flavor he brings to his canvas emphasizes a special diversity of artistic approach particular to the American southwest, adding an adapted zest from refinements of the social and historical atmosphere of his neighboring land.

 While *New Art International* has, from its inception, celebrated artistic achievement in any nation within which it may arise, it is work like Romero's affecting representations which best illustrate the lively contributions to American culture that migrating visionaries can bring. This sounds an ever more poignant note in a year when immigration has become a touchstone political issue, when rhetoric turns to dark plots hatched by multinational corporations to use migrants as economic levers to keep wages low and social order distinct. As scapegoats and fashionable tools of political forces in wave upon wave of ancestral backgrounds that have arrived in the United States seeking a brighter future, immigrants bring their own cultural values and traditions into the mix. Too often lost in the din of the debate is the enrichment and strengthening of life qualities the most positive aspects of an infusing culture brings to the American spirit. Such qualities are conspicuously evident in the uplifting anima of Romero's waltzing brushes.

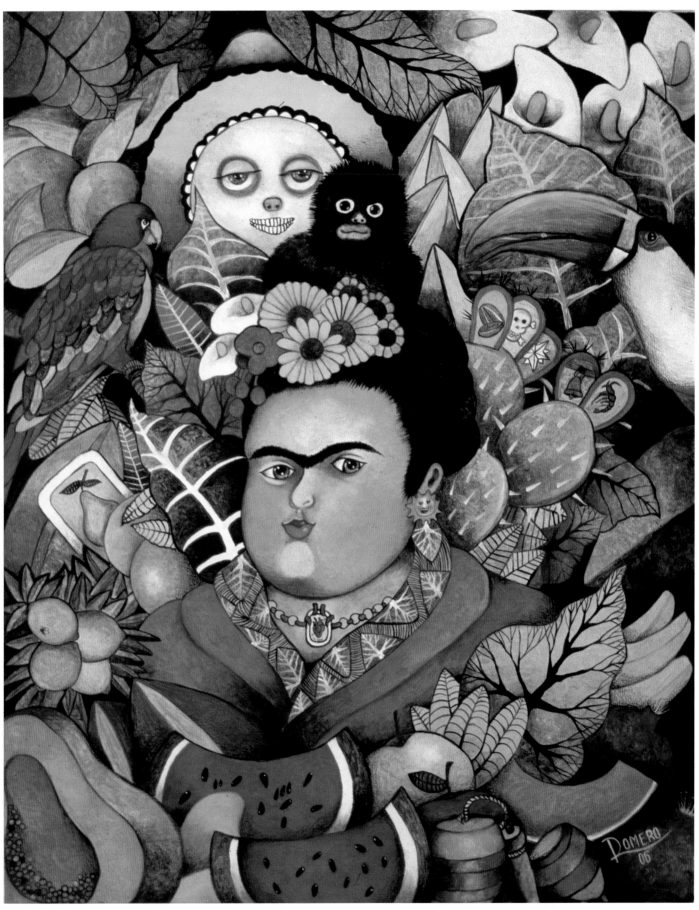

Fat Frida 30" x 24" Oil

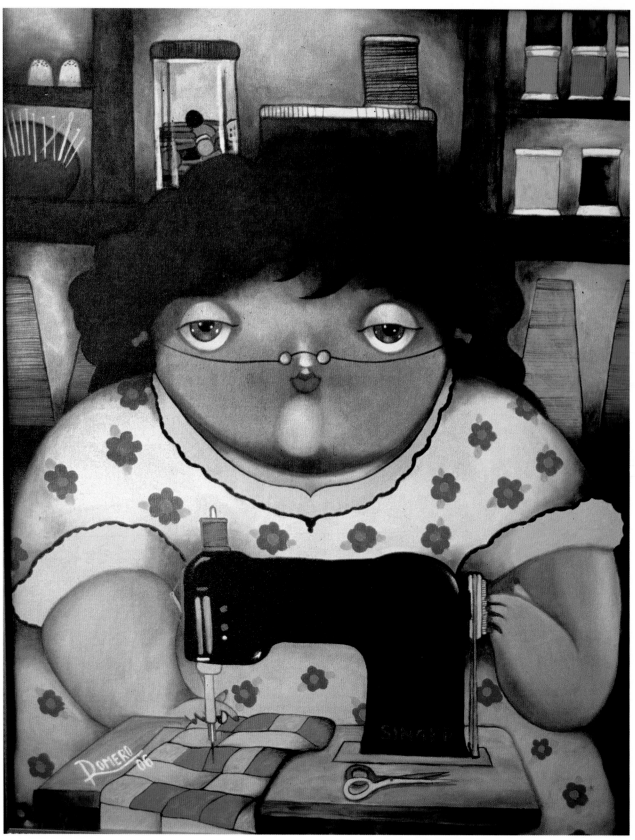

Elvira 22" x 28" Oil

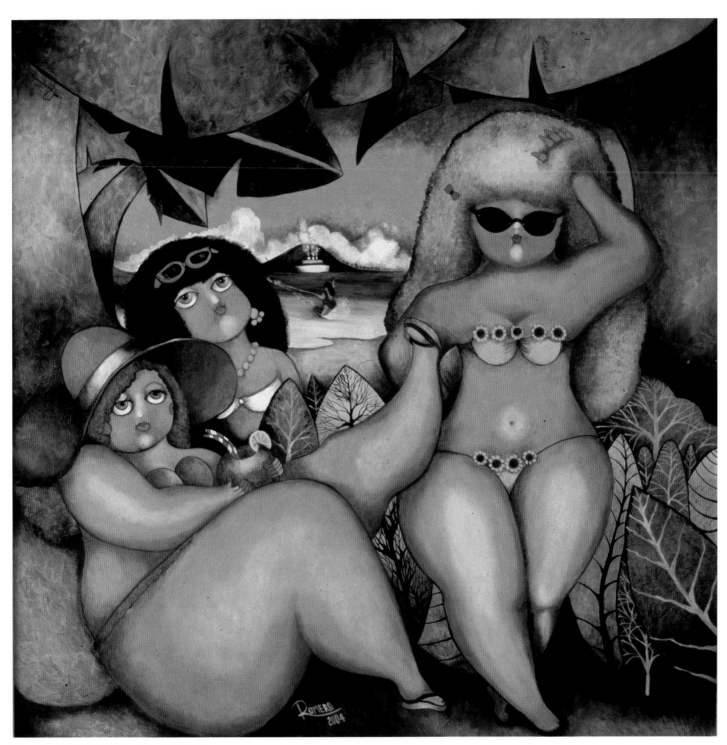

Cuando Calienta El Sol 48" x 48" Oil

Romero's knowing use of the psychology of color provides undertones of refuge even in a scene of ominous intent, such as the poster and soundtrack cd cover for Cesar Alejandro's 2005 independent film about a sinister series of events in Romero's boyhood hometown; *Juarez: Stages of Fear*. Applauded by those who felt Alejandro's fictionalized take on a very real plague of abduction and murder was too urgent a social issue to be continually swept under the rug, (an appreciation which would not be naturally shared by the Juarez authorities), Romero's painting captures the unnerving menace of the situation while providing keyed avenues of redemption and escape with a sensitive balance of space and tone.

Bearing the name of a famed Spanish matador of the early 18th Century as well as a physician of Catalonia who performed the first heart operation in the Age of Napoleon and a widely read Latin American philosopher of the recently passed century, Francisco Romero's brushes are raised to stroke that same name, his own, into the world-wide annals of art in a new land and an even newer time.

—*G. Alexander Irving*

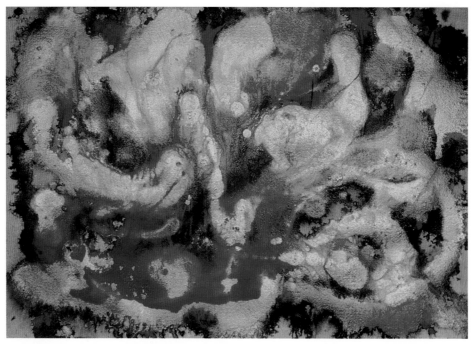

Underworld 34" x 25" Ink on paper

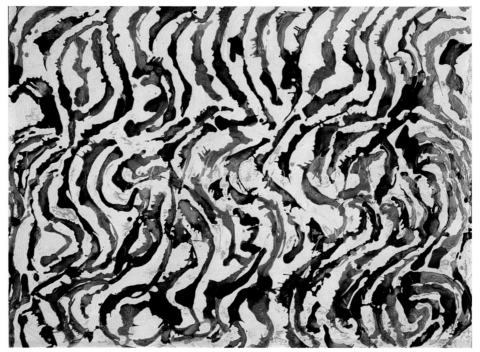

Tribal Waves 43" x 32.5" Ink on board/mixed media

TERESA CHIPPERFIELD

A mother of 3, Teresa Chipperfield was born in England and has spent her adult life in North America. She works in mixed-media techniques and regularly displays her work in galleries and coffee shops around Portland, Oregon. She has taught after school enrichment programs in quilting, watercolor and sculpture, won first place in Mixed Media Abstraction at the North Clackamas Art Guild in 1999.

My artwork reflects my life as a Woman, Mother, Wife, Daughter, Sister and Friend. The art evolves into a piece with raw emotion and passion reflecting my struggles and determination to enjoy a full loving life.

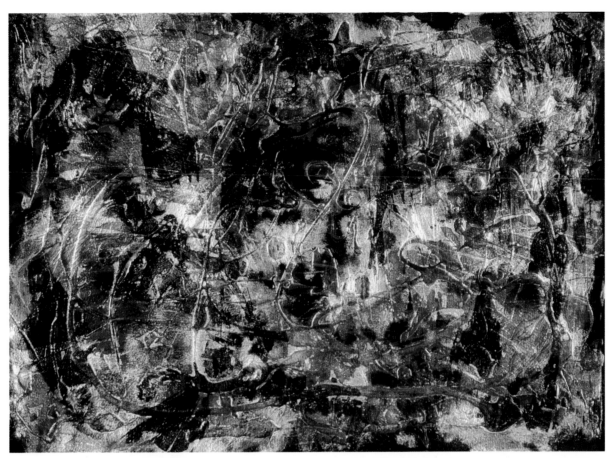

Arizona Heat 37.5" x 29" Mixed media

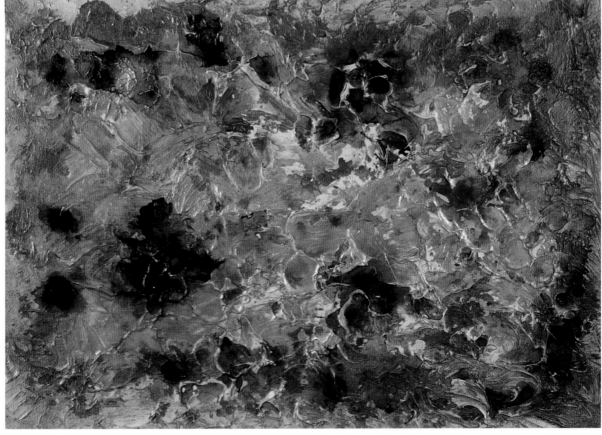

Spring Blossoms 46" x 33" Mixed media

Eros and Venus 38" x 32" Oil on canvas

Abduction 30" x 30" Oil on canvas

Traffic Controller 42" x 38" Oil on canvas

Quintet 58" x 40" Oil on linen

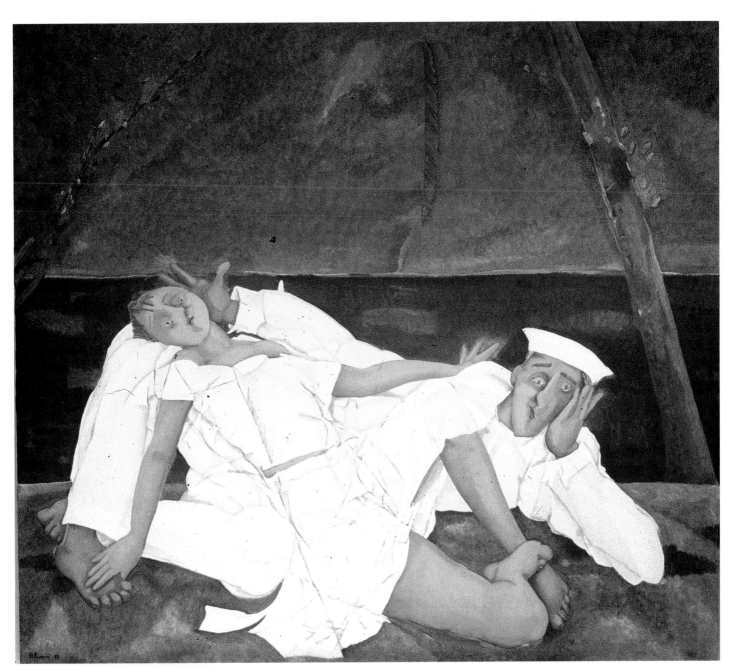

The Spa 60" x 68" Oil on canvas

SERGEI BLUMIN

A native of Russia, Sergei Blumin developed first as a musician who played with the St. Petersburg Philharmonic and the Kirov Opera and Ballet Theater. While studying at the Moscow Conservatory, Blumin admired the artwork of Kandinsky and Klee and was inspired to produce his first painting. In 1974 he joined the Union of Artists and created miniature metal sculpture, which was exhibited throughout the former Soviet Union. Emigrating to Europe in 1978, Blumin showed his work in Vienna and Florence. The next year, he settled in New York City, where he evolved as a painter.

Blumin has had eight solo exhibitions in Russia, Italy, Austria and France, as well as many solo and group shows in the U.S. His work is included in the collections of The State Russian Museum, St. Petersburg; The State Historical Museum, Moscow; the Museum of Applied Arts, Vienna, and Bucknell University, Lewisburg, Pa.

I am attracted to primary, basic human emotions, but not to destructive ones like anger or hatred. I strive for harmony, even in dissonance....

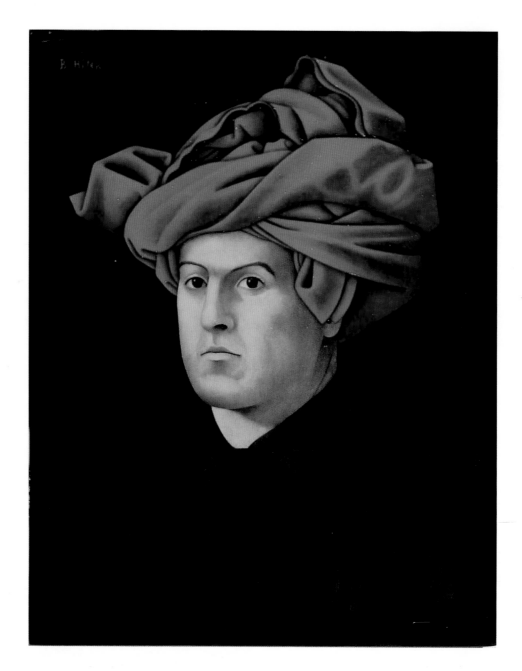

Brian Hinkle: Revelations in a Realist

The achievement of the old masters finds new meaning in the work of Wichita-based artist Brian Hinkle, whose figurative paintings manage—without irony—to bring an Italianate sonority of color as well as compositional strategies redolent of Jan Van Eyck to the neatly plowed fields and clumped vegetation of the American Midwest.

Often Hinkle's figures are poised as though émigrés from the iconographic universe of European altarpieces—and it would seem they might exist more comfortably in a devotional context, in work intended to charm a pope. And so, it is with some uneasiness that these figures occupy Hinkle's mythic farm country—with its familiar, unmistakable attributes which range from the firmly constructed barn to a slice of pie on a simple table. This incongruity, however, is basic to this work, and is at first glance its most intriguing quality.

Brian Hinkle was born in Kansas in 1964, and has lived in prairie states most of his life. One cannot look at his paintings, and in particular, the way he communes with his native landscapes, without being reminded of the *American Scene* painters of the 1930s. Schooled in the democratic principles of mural painting, these painters strove to render their rolling expanses of verdure and brooding skies in ways that might be comprehended as truthful, or spiritually correct, by actual farmers. Thus with Hinkle, the nuances of coloration and shading that imprint a specific character upon the good earth seem also to meld with the mood of the sky, whose providentiary cycling, one senses, is potentially fitful and seldom impassive. It is indeed by dint of the sheer feeling with which Hinkle vaults his firmament that a psychic unity of heaven and earth is realized—through which the stoic meditations of his pioneer-spirited subjects are inflected.

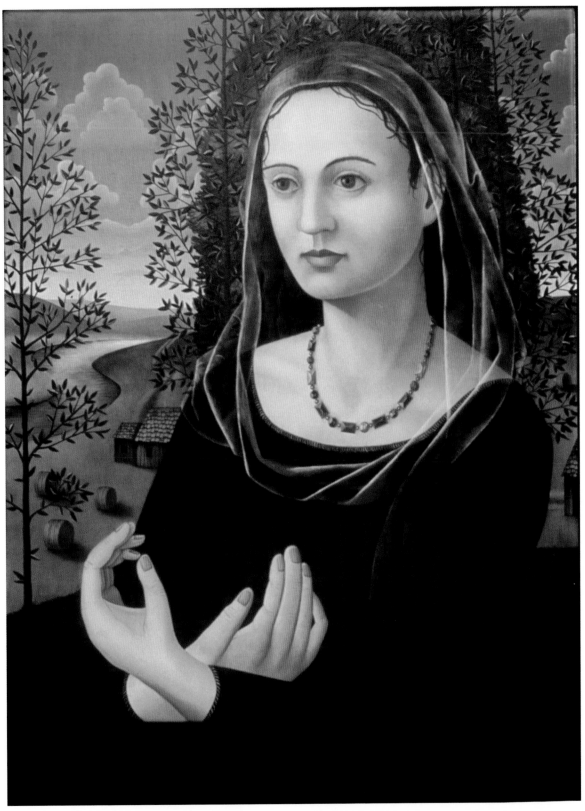

Homage to Anonymous 18" x 15" Oil on panel

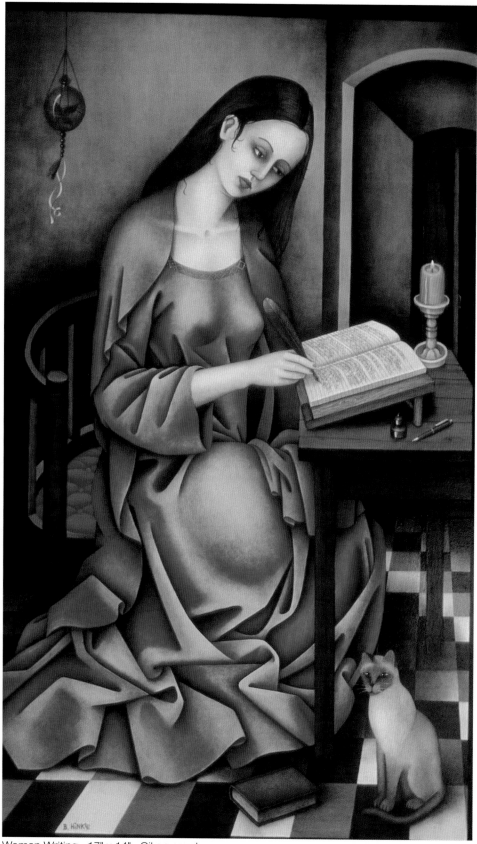

Woman Writing 17" x 14" Oil on panel

BRIAN HINKLE

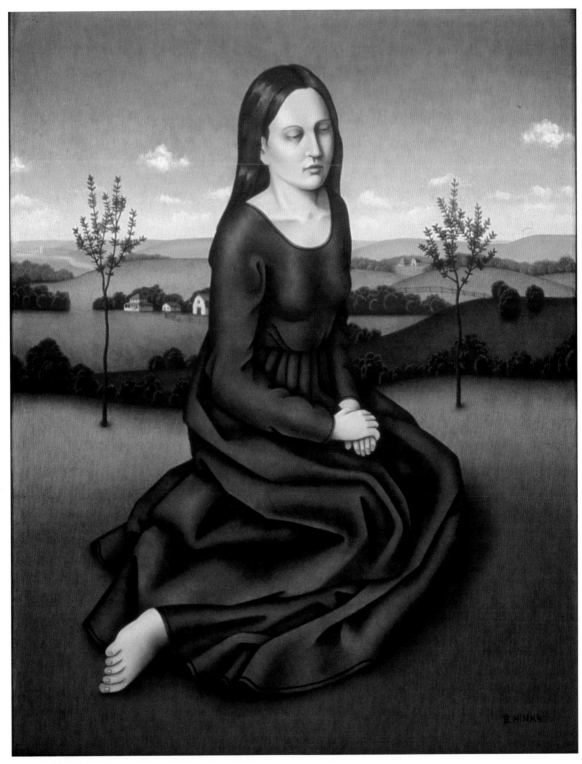

Woman with Green Dress 14" x 11" Oil on panel

The *American Scene* artists famously eschewed Europeanization in art and relentlessly sought to ennoble homegrown subject matter. Today the regionalist impulse of that movement is most readily identified with Grant Wood's *American Gothic*. But despite his ties to these earlier heartland realists, Hinkle channels the well-springs of European Art History without bias or reservation. After all, the ideological landscapes of art underwent drastic shape-shifting over the course of the 20th Century; what were life and death issues to Depression-era polemicists generally are not important concerns for contemporary generations. It is no surprise that a painter of Hinkle's virtuosity would find aesthetic relevance in the classics. What is surprising, however, is the ease with which Hinkle translates formal effect and sensuality of color from Flemish and Venetian easels of the distant past into an American-rooted idiom. The artist is so successful in this syncretistic program in fact, that the viewer is led to reconsider the Old World models as if looking backward through a prism of American art. Is there, for instance, a correlation between Titian's matted greenery and Thomas Hart Benton's agrarian scenes than one would not have heretofore been apt to imagine? And if so, what might a cognate pairing such as this one ultimately suggest?

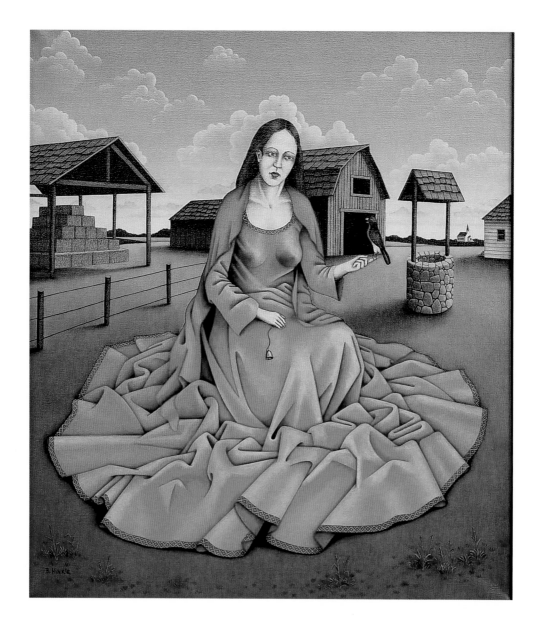

One realization that comes with being re-attuned to these sorts of historical correspondences (and re-attuning the viewer in this way is exactly what Hinkle's work does) involves the likely mission, or possible role, of the realist painter at the start of the 21st Century; in particular, that in the post-abstractionist, post-minimalist present, now that the bygone debate as to whether or not realistic art should even matter at all is itself an historical curiosity, it seems that the realist's agenda, in part, is simply to honor the oil painting medium—its craft, its techniques, its most inspired practicioners.

Through his soft brushwork and subtle manipulation of pigment, Hinkle brings the jewel-like reds and blues of *quatrocentro* Madonnas into Kansas barnyards and clapboard farm towns without contradiction. Even his glazing technique, one suspects, is an alchemical secret from the past that the artist humbly keeps within the domain of his expertise.

Also derived from the old masters are the angular masses from which Hinkle creates folds in dresses. It is little surprise that mathematics was the artist's major in college—a knack he shares with his Renaissance predecessors. In observing the complex patterning of light and shadow, the viewer fixates on unexpected symmetries and geometric rhyme schemes. The clothes themselves, which clearly nod to recognizable styles from High Gothic *couture*, cannot generally be placed in a definite historical timeframe. The red dress of his *Madonna of the Farm*, for example, might as easily belong to a small town homecoming queen as an aristocratic Florentine matron. In certain works, however, the period designation of the clothing is more precise. *Self Portrait With Red Turban* shows the artist, with an intense expression and a masterly application of beard stubble, wearing a regal Orientalist headdress and a plaid flannel shirt. The blatancy of this anachronism is undoubtedly intended—but a level of figurative logic offsets its absurdity as one considers the fact that Hinkle's turban is directly copied from a portrait by Jan Van Eyck.

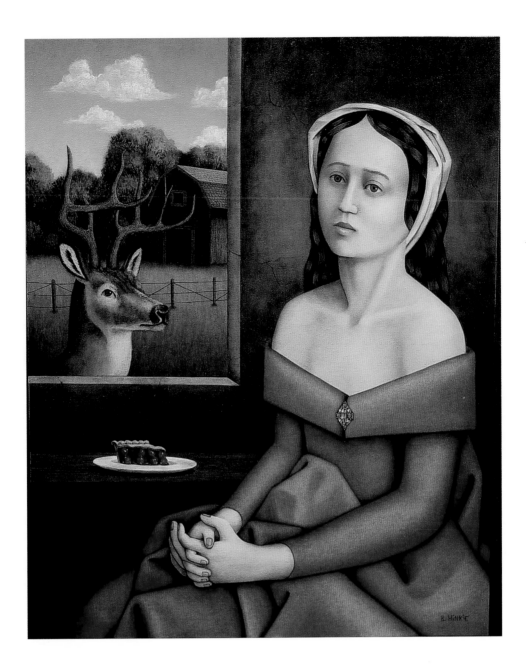

For Hinkle, one surmises, it is not a matter of the past being more exalted, more artistically mature, or more spiritually in-touch. Rather, it is that the past, given the vast, rich tradition of realistic painting to which he perpetually alludes, provides him vivid, irresistible opportunities for great dramatic effects. In the faces of his subjects one tends to find an unsettling conflation of pictorial conventions. His women's brows are high and smooth and their cheeks flush healthily—reminiscent of a hundred youthful Marys. But their mouths are somewhat grim; for were there to be occasion for a smile, it probably would not be a tender smile. The ovoid faces with their tight little features strike into the light with a degree of fierceness. The eyes are never sweet or languid, and instead are knowing, agitated, or perplexed.

In *Woman With Young Deer* a beautiful stag has arrived at a woman's window. She is stunned by this almost supernatural intrusion. The white cloth covering her head denotes membership in a religious community. It is possible she is overwhelmed with a sort of puritan angst as the deer proffers a true calling. A slight disparity in scale between the deer and the woman—that is, the animal being a fraction too small—places emphasis on the deer's symbolic function, and in turn helps open a variety of interpretive possibilities. The picture practically demands a copious narrative response.

Just as the stag, in a sense, has alerted the seated woman to perilous life-giving waters that are already half-known to her, and which cause mild cataclysms within, Brian Hinkle's artwork challenges us, with very old means and profuse emotion, to thorny takes on nature, domesticity, and the divine—which sometimes are startling.

—*Marx Simao*

Ruth & Boaz 24" x 34" Oil on canvas

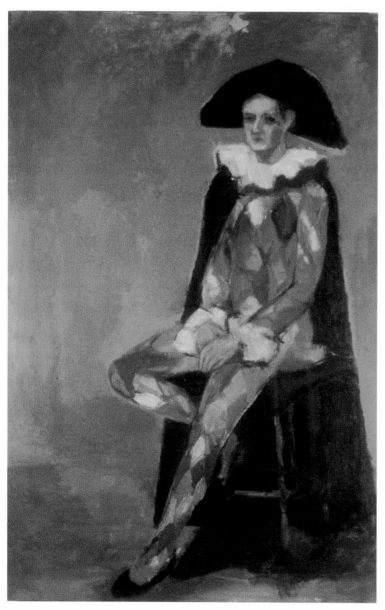

Harlequin 24" x 34" Oil on linen

Harvard Divinity School 18" x 24" Oil on linen

MARGARET ANNE THOMSEN

The artist earned a B.F.A. in Communication Arts and Design from Virginia Commonwealth University and an M.F.A. in Painting in Art History from the Parsons School of Design. Her work is exhibited at Amsterdam-Whitney International Fine Arts of New York City; the Rockland Center for the Arts in West Nyack, N.Y.; Anderson Gallery of Richmond, Virginia; The Thomsen & Hoyt Gallery of Tappan, N.Y., and others venues.

Margaret Anne Thomsen enjoys nature, it shows in her poetic abstract landscapes. Her painterly approach comprises a keen sense of form and a love of movement.

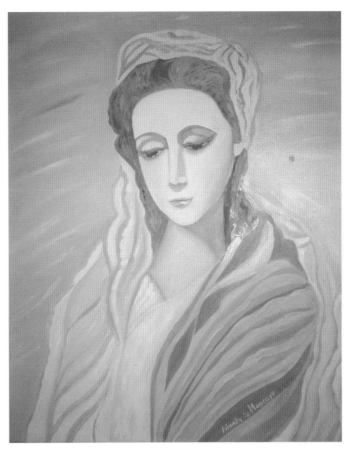

The Virgin Mary 36" x 28" Oil

YOLANDA MONCAYO

A native of Ecuador, Moncayo began to paint when she was 4
years old. Soon she was painting in chalk, watercolor, tempera,
and oils. Later she moved to the U.S. and studiesd at Ohio
University, where she added ceramics, printmaking, and acrylics
to her skills. Her work has been exhibited widely in 2006, and
she has a permanent exhibit at Half-way Sun Gallery, in
Nelsonville, Ohio.

*I love to see the constant transformation of the world around
me through the magic of color and light, and I express that
love in my painting.*

SCOTT LANDOLL

A natural artist and rock singer, Scott Landoll was born in Ohio in
1971. In high school, he used charcoal to draw famous people.
Through the years, Landoll has sold portraits from his home
studio. His work was well received by "Art Without Walls" in
Central Park, New York City in 2005. In the 1990s, with a band
called Shooting Stars Variety, Landoll received a Trailblazer Award
in Nashville. Later, one of his music producers received a
charcoal of Elvis. The comment was, "I met and knew Elvis and
it's dead on."

*I work in several mediums, including charcoal, oil and
watercolor. I like to do landscapes and portraits. I owe my
talent to God.*

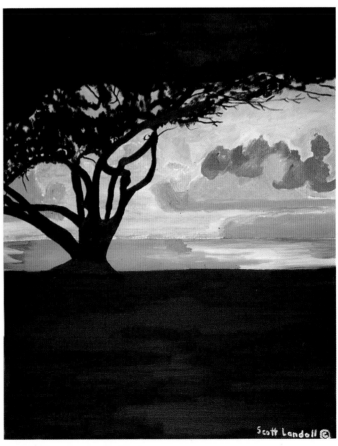

Sunrise Scene 24" x 30" Oil

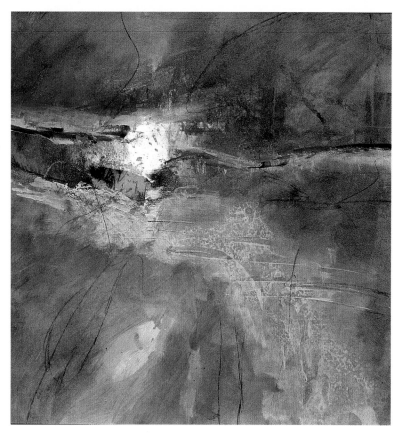

Blue on Blue 22" x 22" Mixed

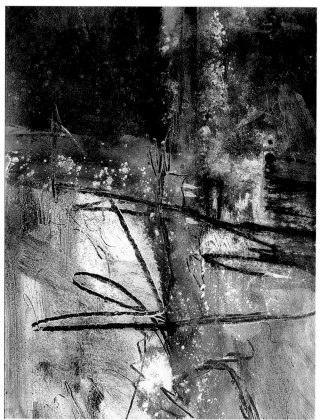

Sidewalk Series I 29½" x 20" Acrylic

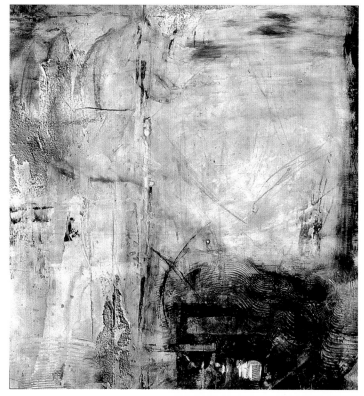

Sidewalk Series IV 22" x 22" Mixed media

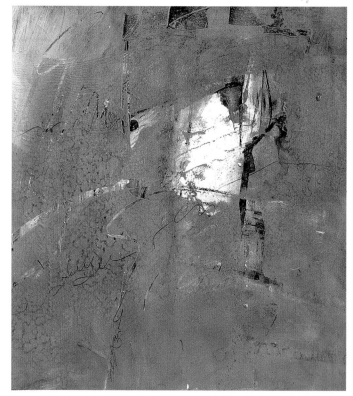

Sidewalk Series VIII 22" x 22" Acrylic

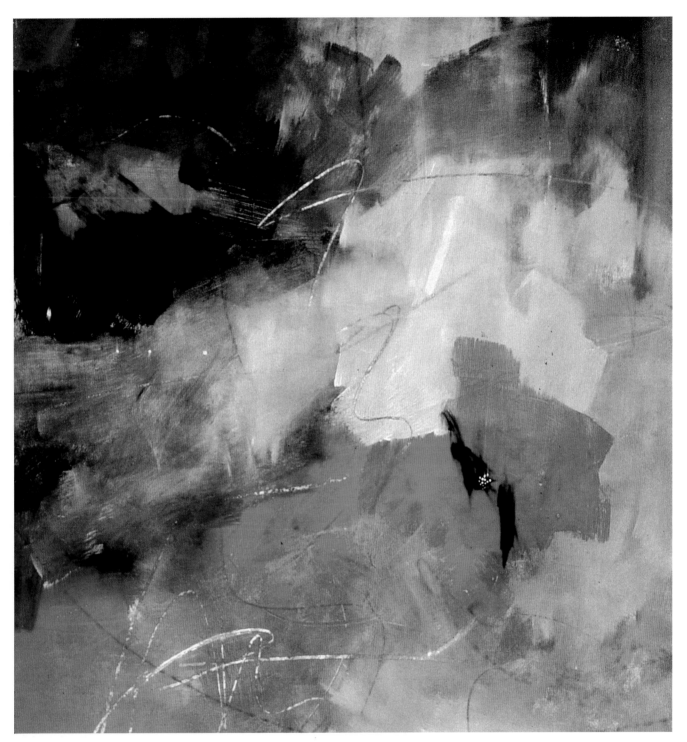

Intuitive 22" x 22" Acrylic

CAROL STAUB

Carol Staub brings a vivid imagination, deep intuition, and a fluid, unconventional flair to painting and collage. Originally a jewelry designer and fabricator, she invents her own visual arts techniques and demonstrates unique skills along with a soulful mastery of traditional methods. Staub has studied with several renowned artists, yet remains essentially self-taught. The artist's biography will appear in the 2007 edition of *Who's Who in America*.

Staub currently serves on the Board of Directors of the Florida Chapter of the National Association of Women Artists, and is a Signature/Full member of numerous arts organization, including The Boca Raton Museum of Art Artist's Guild and the International Society of Acylic Painters. Her works are in private collections and can be seen in museums and galleries throughout the U.S. and abroad. Staub resides with her husband, Bill, in Somerset, N.J. during the summer and winters in Port St. Lucie, Fl.

For me, there are no preconceived ideas. I allow my subconscious to guide me down the path and I listen to my heart….Enjoy the journey.

Adele 30" x 40" Oil

JOHN PETERS

During the early years of John Peters' career, he sculpted, concentrating on wood and bronze, and taught in the Residents Program at the University of Toledo in Ohio. John received his arts education from the University of New Hampshire. In the1980s he began expressing his "sculptural forms" in strongly colored paper and cut-out collages. Finally, he took out his paint kit and put 20-year-old paints and brushes to work. The past 15 years, using oils, have been his most exciting and productive years.

The paintings are strong on form, color and composition. There is often a subtle sub-text that gives his work greater value than its obvious decorative power. Peters had solo exhibits at the Dolan Center Gallery, Long Island, N.Y. in 2001; the Ambleside Gallery, Grosse Pointe, Michigan, 2002; and at The Cascades, Telluride, Colorado in conjunction with the 2002 Telluride Film Festival. In 2004, Peters was selected as a Chelsea Global Showcase Competition Winner at the Amsterdam Whitney Gallery, Chelsea, NY.

In 2002, Peters co-authored a book, *The Hand-Painted Photographs of Charles Henry Sawyer* (1864-1954). He is a member of Oil Painters of America and Allied Artists of America. His work has been commissioned and is among many private collections. He and his wife, Christine Consales, reside in the Detroit area.

As I paint each canvas, it is my goal to surprise, delight and maybe cause the viewer to take a breath and hold it for a second or two. This, when I can accomplish it, makes me a happy artist. Each painting has a representational tone, and a style that is expressive, with surreal subtext. My favorite tools are organic sculptural forms and bright primary colors.

Moon Blossoms #2 48" x 36" Oil

Dirk 40" x 30" Oil

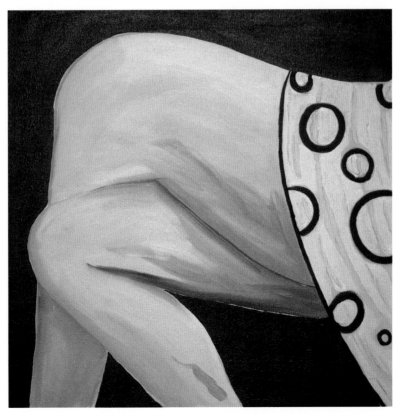

Short Skirt 24" x 24" Oil

Brown Spine 10" x 7¾" Solar Monoprint

Mother & Child 9¾" x 7¾" Solar Monoprint

Paynes & Blue Botswana Vertebrae 7¾" x 5½" Solar Monoprint

L. NOEL HARVEY

Her mother is an artist, her father was a neuropathologist. Growing up in Santa Fe, New Mexico, where her family has lived for generations, L. Noel Harvey could often be found looking through microscopes and playing with paint. Thus she learned how to use her hands and developed a profound interest in the human body. She derives inspiration from a body's innate beauty and the deformities that may lie beneath. Naturally, she combines the creativity of the art world with the detail and precision of the medical world.

Harvey's work has been exhibited in Boston, Caracas (Venezuela), Los Angeles, New York City, the San Francisco Bay Area, Washington, D.C. as well as Santa Fe. Also, her work has appeared in publications, both domestically and abroad, and she has completed several residencies at the Santa Fe Art Institute, where she later served as Assistant Director.

Art is my pathology. My studio is my laboratory...it is the place where I can investigate, dissect, experiment, and understand my past, present and future.

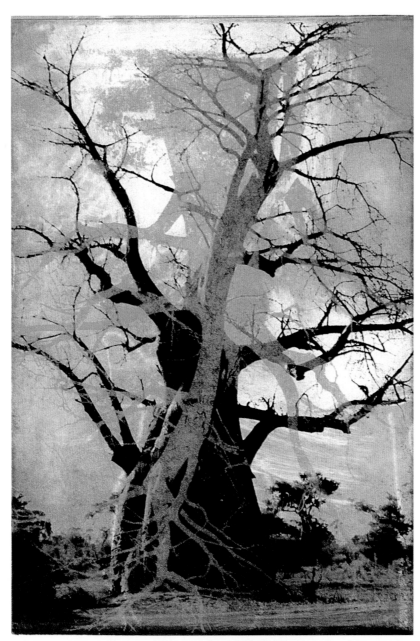

Blue & Black Baobab 8¼" x 5⁵/₈ " Solar Monoprint

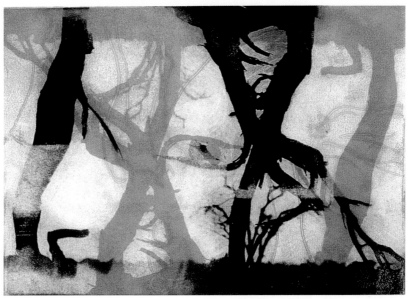

Blue & Orange Kwando Trees 5½" x 7¾" Solar Monoprint

Through the Oaks 36" x 42" Oil on linen

Edge of the Woods 42" x 36" Oil on linen

PAMELA HART

As a child of an army officer, Pamela Hart grew up all over the world. She began drawing and painting at a very early age, and received formal instruction at several schools, including the Art Institute of Kansas City. She earned a B.S. degree with a specialization in Painting and a Masters of Art Education from Ball State University.

Hart's work is shown in galleries in Chicago, Carmel, Ca.; Ashville, N.C.; Knoxville, Tn., and Fish Creek, Wi.. Her work has been collected by museums, officials from U.S. Presidential administrations, rock musicians and major corporations. She has received numerous awards and recognitions.

The Impressionists and the Flemish painters of the 15th and 16th centuries have greatly influenced me…I try to evoke the feeling that the viewer could just walk right into my work.

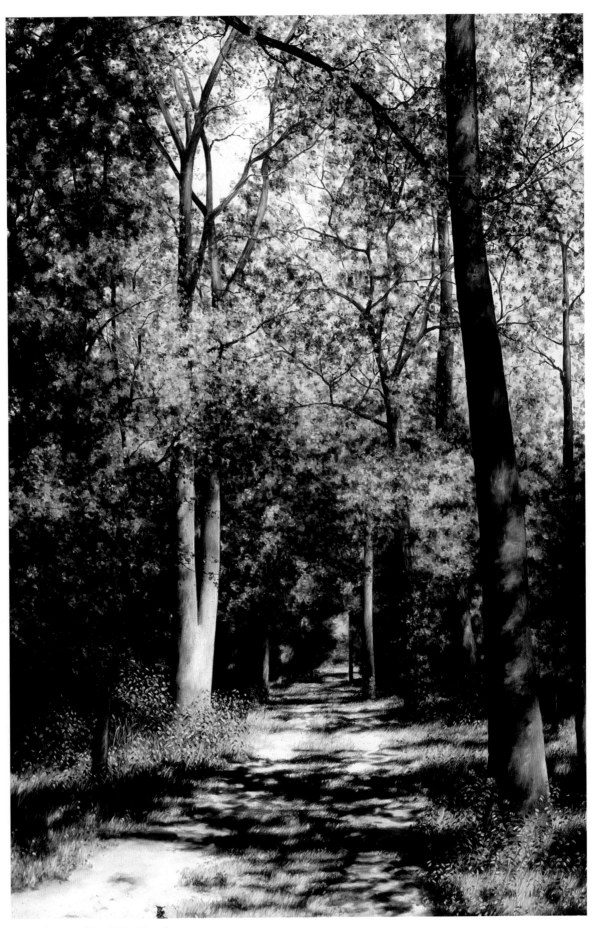

Forest Road 42" x 28" Oil on linen

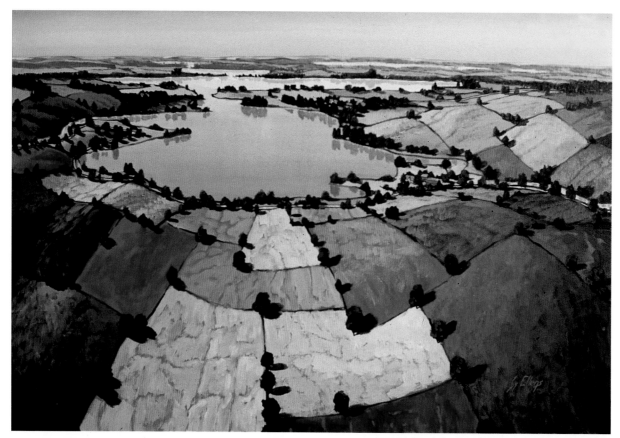

Down to the Lake 46" x 62" Acrylic on canvas

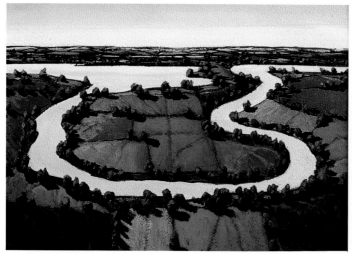

Around the Bend 13" x 19" Acrylic on watercolor paper

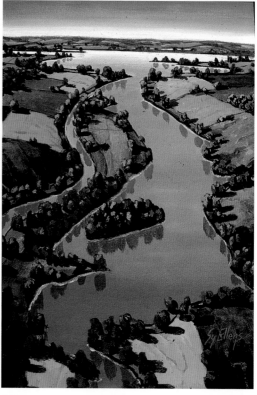

Different Paths 19" x 13"
Acrylic on watercolor paper

SY ELLENS

Sy Ellens graduated from the Kendall School of Design in Grand Rapids, Michigan and worked as a commercial artist. He went on to earn a degree in art education at Western Michigan University. After teaching high school for several years, he moved to Nigeria and taught at Vandeikya Government Teachers' College, and later in China. Ellens' work is in collections around the world, including those of Upjohn and Allied Capital. His paintings have received the American Watercolor Society High Winds Award, and have been included in exhibits at the Salmagundi Club of New York, The American Artists Professional League, and others.

God gave me the ability and desire to draw, so I have been doing just that for as long as I can remember.

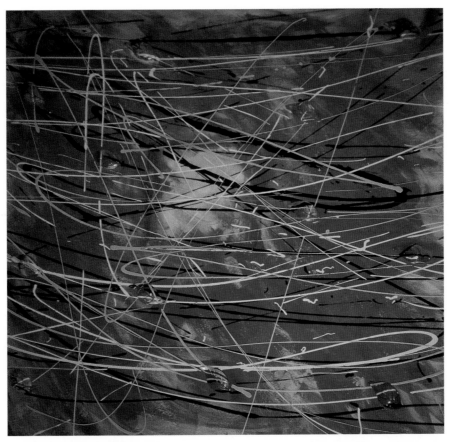

Hidden Wind 42" x 44" Acrylic

Untitled 36" x 46" Acrylic

Love Me With All My Flaws 16" x 20" Acrylic

TAMMY DUFFY

Tammy Duffy is a self-taught artist with a Ph.D. in Physics whose experience in the scientific field helps her to refine and express a myriad of visual concepts through abstract painting. Born in Trenton, New Jersey in 1966, Duffy was taught by her father, an industrial engineer, to value others' creativity as well as her own.

Since Duffy began painting ten years ago, she has had solo exhibitions at the Paterson Museum, Paterson, N.J.; at the Long Island Science and Technology Museum, Garden City, N.Y.; and at the First Annual Long Island Tech Fest. Her work is held in permanent collections at the Chelsea Art Museum and the Paterson Museum. She has participated in group exhibitions at the Brewster Gallery in Philadelphia; Agora Gallery, New York City; Cork Gallery, Lincoln Center, New York City; and at the Dark Horse Creek Gallery in Erieville, N.Y., The Amsterdam Whitney Gallery, New York City and The Fusion Arts Museum, New York City.

I make abstract paintings that help me to reveal what I feel about the natural world: its colors, shapes, textures, lines, and forms. My background in science supports my visual expressions on the canvas where my goal is to make a connection between myself and the observer. I hope my work inspires the observer, subconsciously or not, to develop his or her own special vision and see beauty where one might not even know to look. My mind is my brush and I use it to create images that transcend the ordinary.

Vittorio-Emanuele (Torta Di Nozze Roma) 74.5 cm x 100 cm Oil on Canvas

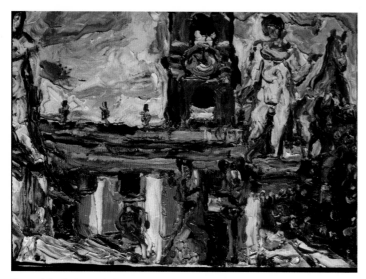

Campidoglio! 18.25" x 26.75" Oil on Canvas

PHILP LAWRENCE SHERROD

Painter, poet and teacher Philip Sherrod, whose work appears in prestigious museums, corporate and private collections throughout the U.S., has taught at the National Academy School of Design of Fine Arts in New York City, the New Jersey Center for Visual Arts, and the Arts Students League of New York, among other institutions.

After earning a B.S. in Zoology in 1957, he changed direction and received a B.A. in Art/Painting from Oklahoma State University in 1959. He soon moved to New York, where he studied at the Art Students League from 1961-1963. He found instruction stultifying, and so in 1977 he founded the energetic "Street Painters," a group of eight who paint on location in New York City. The group has had more than 100 exhibitions since then, most recently in 2005-2006 at the Cork Gallery, Lincoln Center.

In a prolific career that ranged from his first art University award in 1959 to participation in the National Academy School of Fine Arts Master Class Instructor's Exhibition in 2005-06, Sherrod has been recognized in exhibitions and awards practically every year. His work is in the collection of the Rhode Island School of Design, the Newark Museum, Paramount Picture Productions, the private collection of Allan Stone, and others too numerous to mention.

I wanted to get back to the people. I went to the street.

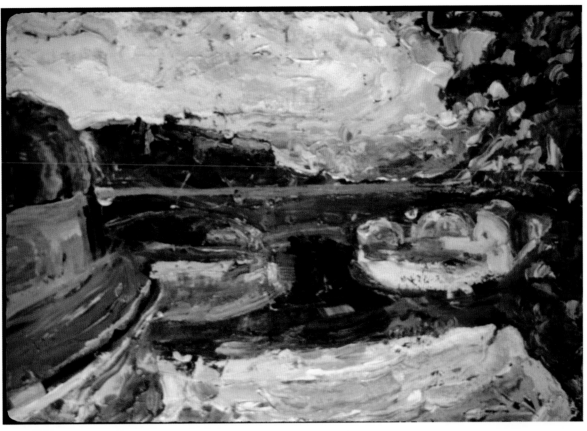

Il Levar Del Sole (Ponte Garibaldi, Roma)! 19.6" x 27.1" Oil on Canvas

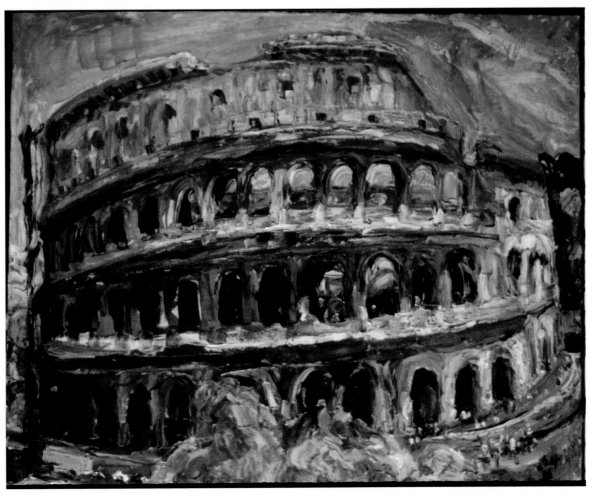

Colleseo,Roma! 75.5 cm x 103 cm Oil on Canvas

Bernard, I Am Very Sick 16" x 20" Mixed Media

Healing Garden 16" x 20" Mixed Media

Hope Tree 16" x 20" Mixed Media

RICHARD FORAND

Perhaps in an attempt to understand the pain of his childhood and the recent loss of both his sister and his wife to cancer, Richard Forand creates mixed-media pieces on the subject of his family. These projections start with a family member's photo image. The artist improvises from there, using juxtaposition and combining real and imaginary experiences around the image of each family member. He has created a visual series of his dreams, a record of daily visual experiences during this period. Written words explain some of the images.

Forand was born in 1952. He earned a Bachelor of Fine Arts from the Massachusetts College of Art in Boston, Massachusetts in 1980, and a Master of Fine Arts from Pratt Institute in Brooklyn, New York in 1984.

This show theme is about healing our wounded soul. To quote the surrealist painter Joan Miro: "I am convinced that the more individual something is, the more it becomes universal."

Tied Up 24" x 20" Acrylic on canvas

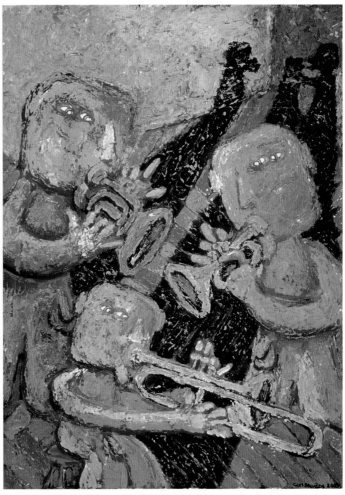

3 Trumpeters 38" x 28" Acrylic on canvas

By the River 24" x 20" Acrylic on canvas

CARL STEVENS

Though born in New England in 1959, Carl Stevens has spent most of his life abroad, engaged in challenges like sailing the Caribbean, living on a kibbutz, or crossing the Atlantic on a ship with 200 Russian cadets. His life has been colorful, his education international, his jobs varied. Recently he managed the Gomez Gallery in Baltimore, Maryland, and worked for a production company in Chile creating concepts for TV programs.

Stevens' work has been shown in Finland, Russia, Poland, Austria and South America as well as the U.S. One of the 25 finalists out of 2,500 entries, chosen by Robert Rosenblum, curator of the Guggenheim Museum. Carl has exhibited in New York City. Recent solo exhibits were at the City Café in Baltimore, The Garden Café in Santiago, Chile. His work is in private collections throughout the world.

The internal state of the artist cannot be separated from that which he produces. My best motivation is my own soul, for content, color and composition.

Wild Iris 20" x 24" Oil

Confetti 24" x 36" Oil

Lillies 24" x 36" Oil

THERESA LUGO

Theresa Lugo's earliest memories are of painting and drawing. She studied at Iowa State University's School of Design, and served in the Marine Corps in the 1st Gulf War. Now a resident of Parker, Colorado, she has joined the Parker Artist Guild, studies at the Art Student League of Denver, and exhibits her work at the Main Street Center Gallery in Parker, Painting Up a Storm Gallery in Frank Town, and Next Gallery in Denver.

I enjoy painting works of art that verge on abstractions and are inspired by things that I like. Experimentation is an ongoing fascination....I am continually trying to grow as a person and an artist.

Fireworks 4' x 4' Mixed

STEVE KRAJDA

A one-time resident of New York City, Steve Krajda has now resided in Broward County, Florida for the last 20 years, and is a member of the Coral Springs and Boca Raton Artists Guilds. He is a graduate of Sacramento State College, served in the U.S. Air Force, and worked for the McFadden-Bartell publishing company in New York City. Krajda's work has appeared at the Cornell Museum in Delray Beach, Coral Springs Museum of Art, Broadway Gallery, Ft. Lauderdale; Art Serve, Sunrise; and at the 54th Annual All-Florida Juried Competition and Exhibition, Boca Raton Museum of Art.

The art work is called Linear Non Linear, which infers every straight line has no finality…it just keeps moving…it has no beginning and it has no end. Every line has an ebb and flow, radiating from one or many different points on the canvas.

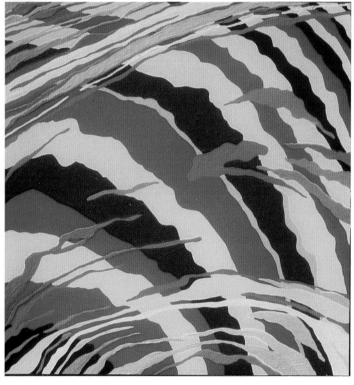

Looking into a Glass Ball 3' x 3' Mixed

Glass Flowers 3' x 3' Mixed

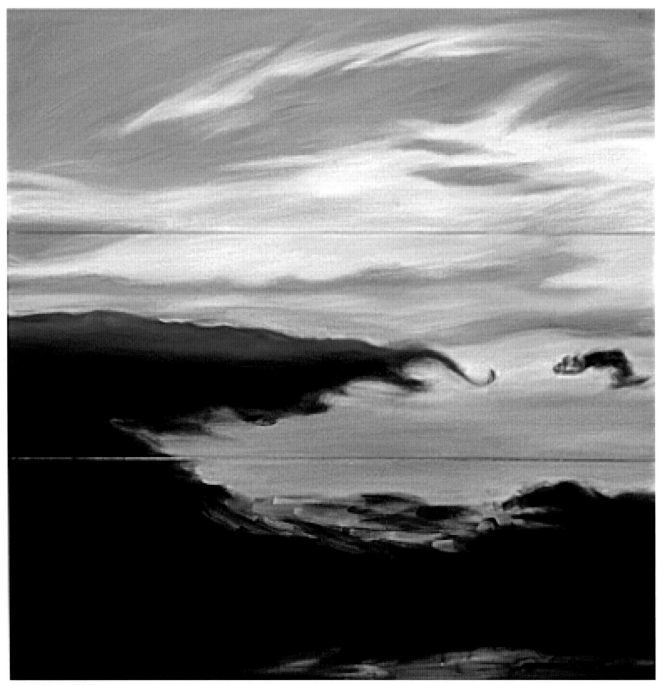

Sky Light 36" x 36" 3 Panels, oil on canvas

LOUISE LINK RATH

This New England-based artist started out as a student at Bard College, creating large, abstract paintings on raw canvas. Then she earned an M.A. degree in Social Work from Columbia University. Gradually, two decades later, Louise Link Rath returned to the field of art, using mixed media on paper to tell private stories through symbolic imagery. Once satisfied that her stories were told, she emerged as a landscape painter.

She received the Best in Fine Arts Award at Art on the Mountain, Wilmington, Vermont in 2001; several awards over the years at the Fitchburg Museum's Regional Exhibitions of Art and Craft, Fitchburg, Massachusetts; at the AVA Gallery, Lebanon, New Hampshire; and at the Thorne-Sagendorph Art Gallery, Keene New Hampshire. Her work was shown in 2006 at Forest Society, Concord, N.H., at Sunflowers Café, Fitzwilliam, N.H. in 2005, and at the Red Roof Gallery, Enfield, N.H., in 2003.

My vegetable and flower gardens are the main sources of recent work, making the focus more intimate, less distant than past land-scapes. All paintings begin with my own photographs. To simply express my personal passion for the natural world is the intent of these paintings.

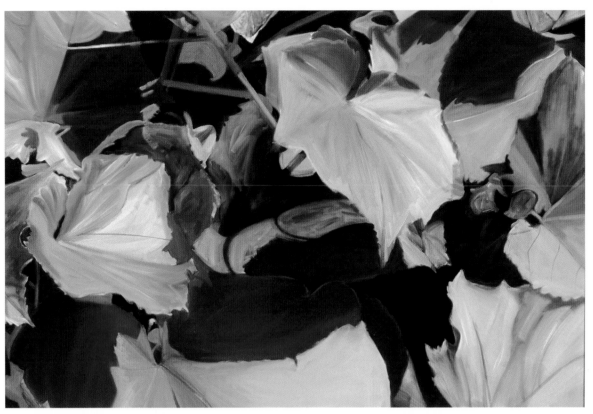

Summer Wealth 24" x 36" Oil on canvas

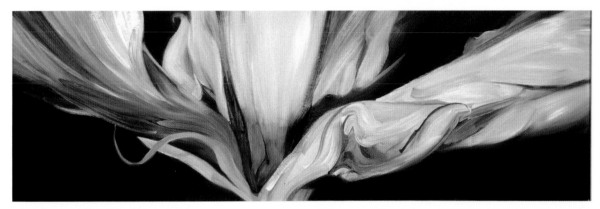

Wing Span 12" x 36" Oil on canvas

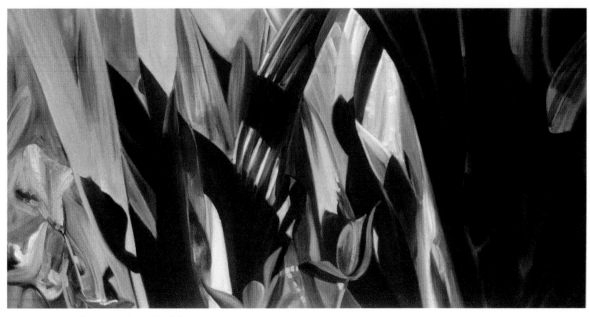

Early Morning Glory 18" x 36" Oil on canvas

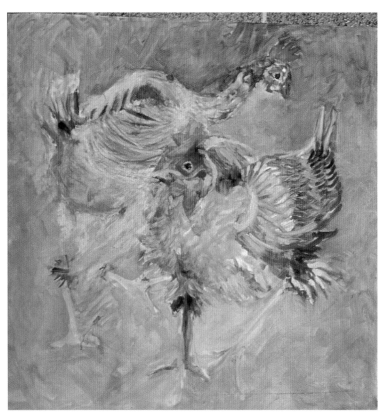

Chickens (Doe Si Doe) 4' x 4' Oil

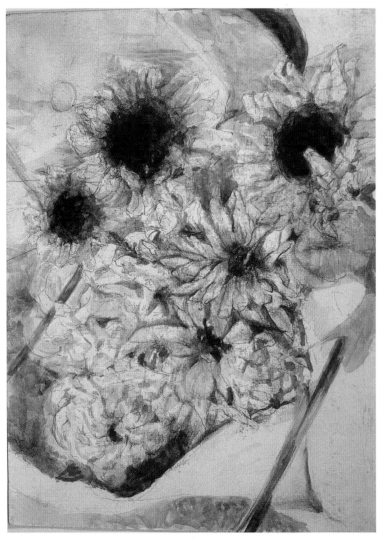

Sunflowers 12" x 16" Watercolor

ALISON SPARROW

Alison Sparrow's paintings are alive with movement and tones that lift the spirit while remaining humanistic, accessible, and ever-grounded to the earthly experience. She graduated early with a B.F.A degree, Advanced Standing, from the Rhode Island School of Design in 1997.

Now working as a fine artist throughout the U.S., Sparrow has been granted artist's residencies and fellowships at the Vermont Studio Center, the Center for Contemporary Artists in North Adams, Ma., the Virginia Center for the Creative Arts, the Mary Anderson Center in Indiana, the Hambidge Center in Georgia, the Anderson Ranch Arts Center, and the Byrdcliffe Arts Colony in Woodstock, N.Y.

Sparrow complements her artistic endeavors with service to the community. She mentors young adults in art and language skills with Literacy Volunteers of America, served as an Intern at the Institute for Unpopular culture in San Francisco, volunteered as a high school teacher in Providence, Rhode Island, and was a volunteer at the Detroit Institute of Arts.

She is listed in the *Who's Who of American Women* in 2004 and who's *Who in America* in 2005 and 2006. Currently, her work appears at the Detroit Artist Market, where last year her paintings were selected for the juried show, "Mike Kelley Selects." She has had solo shows at the Cup-a-Cino Café in Grosse Pointe Park, Mi. and at the Moore Art Gallery in St. Clair, Mi. She was awarded Best of Show Regional Winner of the Hallmark Award from the University of Pittsburgh Museum in 1992. Her sculptures have been shown at the Scarab Club in Detroit.

My work is derived from life, but I believe in creating a special symphony of color to make a window of viewing that does not belong to reality. Symphonies and color combinations are one and the same to me.

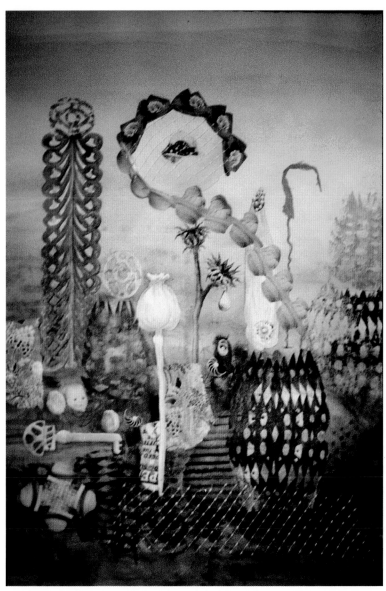

Eye Has It 24" x 36" Collage,mixed media

River Rock 2 25" x 30" Watercolor

VALERIE MEOTTI

Nature inspires this playful, self-taught painter and ceramicist, while graphic arts experience informs the technique of her fine digital prints and collages. Her passion is rooted in watercolor but her versatility with many mediums has kept her seeking new outlets.

Since 1977 she has been creating original watercolor, digitalprints, acrylics and ceramics. Her work has been exhibited on Long Island, N.Y. at the Wet Paints Studio Group, where in 1986 she was awarded Best-in-Show for her watercolors. A collage, "Bluster," was featured in a <u>Newsday</u> art review, Nov. 6, 1988; she received Honorable Mention for a watercolor, "Grandma's Iris," in 1989 at the Islip Art Museum, and she has exhibited collages at the Sands Point Preserve Juried Multi Media Art Exhibits.

I incorporate the beauty and energy of nature's design into a stimulating visual. I love creating something and leaving some of it to happenstance. I am eclectic in styles but always exploring. Exploration is the key to discovery.

River Rock 1 25" x 30" Watercolor

Tibetan Highlands 60" x 68" Oil

HONGNIAN ZHANG, AN AMERICAN ARTIST

There is a dragon hiding in every painting by Hongnian Zhang.

Yes, even in his paintings of Pilgrim settlers in the raw environment of early New England. Gazing at these masterfully painted scenes, one would not expect to encounter the coils of a hidden dragon.

The "hidden dragon" is a flow of light, motion and, frequently, color to be discerned for capture by the eye of an artist. It almost invisibly invites and commands the gaze, compelling the focus and rhythms of attention as the scene is regarded and it beams a triumphant smile as its intended effects are achieved, usually without its own presence being consciously detected.

The hand which traces the mythical reptile's posture in the pilgrim settlement visited here is, fittingly, one which has benefitted from insights ancient and modern, artistic and cultural philosophies worlds apart as well as seasons tumultuous and serene.

Hongnian Zhang was born in Nanjing, China, in the turbid wake of the Second World War as the conflict changed gears in the battle for control of the country from the repulsion of invading armies to a bloody contest between Chinese Nationalist and Communist forces.

"New government, new revolution, new philosophy– everything changed for our family. You can see what happened here," Zhang gestures in his Woodstock, New York, living room, indicating an old photograph he has conjured up to the screen of a laptop computer perched on a coffee table. He points to a babe in arms, saying "That's me with my mother, my father and two sisters. We are in Shanghai, trying to leave (China). My father was educated in the United States. Also, he was a banker and belonged to an older time. He was ready to take us to America but we missed the boat, so our lives are totally changed."

Zhang recalls that his family typically never spoke about their plight as, block by block, the struggle pushed Chiang Kai-shek's forces off of the mainland, or their hardships in the upheaval as the People's Republic of China took root. He expresses a dispassionate lack of regret for the resulting impoverished circumstances of his early childhood because "I only have one life and I grew up in China under Communism, so I couldn't think of another kind of life."

Water Bearer 30" x 40" Oil

Fu Hao's Battle 48" x 96" Oil

Before the Long March 70" x 84" Oil

Despite the insecurity of their own situation, Zhang now recognizes his parents' extraordinary efforts to shelter him from the most ominous shadows of the time, giving him the secure feeling of a beloved child.

"So, I was kind of a 'sunshine boy,' always happy, and I think that was a good beginning because I *liked* everything and I found everything interesting," he remembers. "My parents were not artists themselves but they were both very educated. Another thing that was helpful in my path to becoming an artist is that we were very poor. When you're very poor, you have nothing but imagination. We could not travel. We didn't have tv. So, every day I needed to think– to use my brain and that, I believe, helped me to become an artist."

Remarkably, Zhang can remember his first drawings at two or three years old, making his first marks and saying to himself with a childish exuberance of wonder, "Oh, I can draw!" Because the experience registered so lastingly, he looks at it today as almost a forecasted destiny. "By no means did I draw well but I drew; I showed my dream, my imagination..."

As an evolved master painter, Zhang credits the new communist government with paying vigorous attention to education, an affirmative legacy from his upbringing in the 1950s and '60s which involved him with professional art teachers at children's centers.

"It didn't matter if you had money or not," he recalls, "if you had talent, you got an education. So I was trained very well from early on by a collegiate artist who loved his job and gave me lots of help when I was nine or ten years old until I was fourteen and ready to go on to a more difficult level of instruction.

"Most of the time American people don't seem to understand the kind of system it was under communism," Zhang continued. "In China, and I think maybe in Russia, everything is under the plan. They will decide how many artists are needed. They felt they didn't need too many artists, so they had a very limited number of schools for that. In order to get in, they want to be very sure that you are really talented. That's why my school, at that time, was almost the only art school at the high school level. Out of the whole population, all over China, only thirty students were selected to start in this school, so that is why I say my teacher gave me excellent training because I was able to get into this very select school."

Zhang emits a few of his reserved chuckles as he attempts to compare an art education in Communist China to one in the United States.

"It is not like here, where you can take it part time and pay for it,

Tavern Rest 36" x 46" Oil

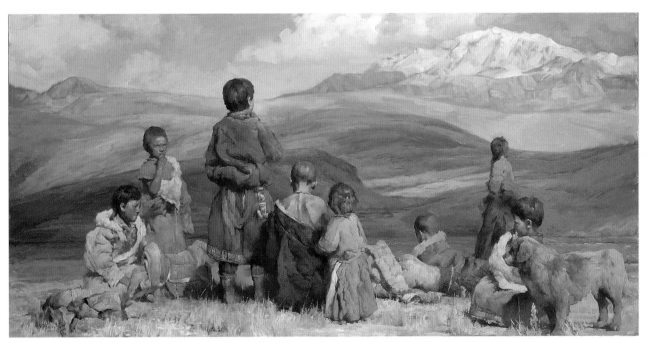

From the Roof of the World 24" x 48" Oil

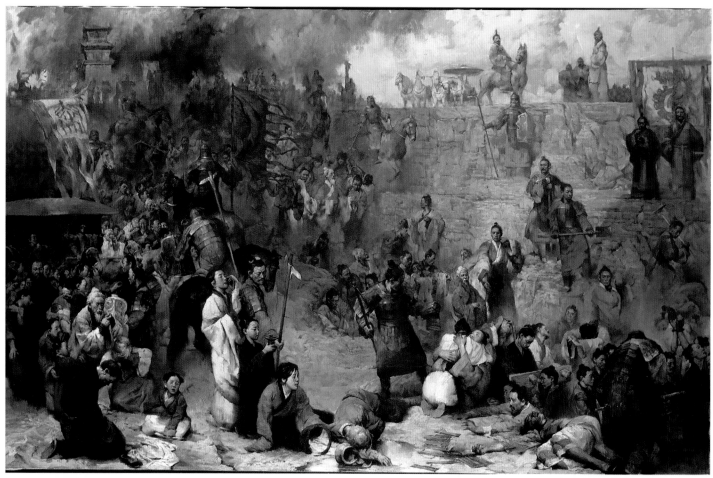

Execution of the Scholars 48" x 60" Oil

if you have money, or get a scholarship and quit, if you want to quit," he laughs. "This is very serious training and you don't have the choice– if you're in then you're in and there's no opting out. It is free but very hard training that brings you almost to professional levels at a young age. Maybe you've heard how the Russians train their ballerinas? It is like that– a long, full devotion from a very young age– concentration on geometric form for hours a day, every day, that kind of drawing for a year– nothing but geometric form and still life. Then, the next year, you follow another detail and your education is formed very gradually. It gives a solid foundation for those skills."

Creativity was not encouraged in this system, Zhang points out. The focus is technique and even thinking about impressionism, about Picasso, or any other such "distraction" is straying dangerously from the beaten track. This rigidity, Zhang feels, was not beneficial for every student because, as he could see, many had developed none of their more creative instincts after years of study. Only ten or fifteen in his class of thirty are still artists today.

"Before the Cultural Revolution, we had good training although the life in China was poor," he observed. "But people weren't feeling the pain so much as yet because it was still a peaceful life and the people felt a sense of equality and purpose. It was as in Cuba today, with free education, free medical care and people feeling equal but equally poor. It was that kind of life."

China's *transitional period* under Mao Zedong's leadership instituted socialist rule, collectivized agriculture and formalized elections that solidified Mao's elevated position. Meanwhile, Hongnian Zhang grew up with a determined focus to learn the myriad secrets of visual artistry. Despite the great social and economic upheavals of his homeland, he continued to be prepared for a career in art until the disastrous decade of the *Cultural Revolution* seized China in 1966.

National Turmoil and "Re-education"

"It was a big mistake for Chairman Mao and a great shock for the Chinese people," Zhang recalls, venturing that personal motives of countering political enemies within the party may have blended with Mao's stated desire to purify the communistic core of the Chinese revolution by rigorously indoctrinating and "re-educating" the masses. "Probably that was all in his mind. It didn't work at all and the whole country was falling apart. It was almost like a civil war for ten years. For us, it was painful because we were not allowed to continue to study."

In fact, education in its traditional sense was replaced with the "Socialist Education Movement"– a work-study program with an emphasis on the work schedule of factories and communes meant to reorder "bourgeois" priorities that favored intellectual activity over labor.

"The government decided that all students had to go into the countryside for 'co-education'– which meant hard labor, to wash your brain, to take capitalist ideas out of your mind," Zhang said of the *xiafang* (or "back to the countryside") program he felt was basically "stupid" in its conception but from which he concedes he was able to recognize some benefits.

"If you're a positive person, you can always find positive

We Were Young Then 35" x 75" Oil

No 111 cm x 128 cm Oil

Woodstock Halloween 54" x 74" Oil

Rite of Spring 32" x 70" Oil

New Home 40" x 30" Oil

The Companions 40" x 30" Oil

angles," Zhang reflected. "I found life is hard, labor is hard and it made me stronger. You don't stop to take a break, have a smoke, listen to some music. You work on and on. Our hands were cramped in a cupped position when we went to sleep because of working all day with shovels, and the next morning the hands would stretch out. In early springtime our bare feet broke the ice into freezing water. It's very hard but you must take it because there's no way out. You cannot run away."

Reviewing the concentration camp-like aspects of his existence during four years of forced labor in the rice fields, Zhang recited the conditions as "no freedom, not allowed to study, no painting, no reading (except, of course, Chairman Mao's own little book– which was dangerous to be without), no freedom of dating, no freedom to go home...All of China was like that."

Zhang's family, he noted, was also dispersed. His sister, who had been in medical school, was in another *xiafang* commune, as was his mother. Both now were also absorbed in *ku li*, as it was called, or "bitter labor."

"So, everybody was in a different place but a good thing happened, also," he said. "I was always a city boy, used to baths and certain comforts and I never really walked all my life but now I was walking in the countryside in my early 20s, getting to know farmers and things important to them. In some ways, you become healthier, with a stronger mind but, most important to me, is that it made me

love painting so much more. We were not allowed to paint or draw anything because, if we are artists for the future, we should have a good communist mind. *Then* we can be artists."

For Zhang, who was poised for higher education when the Cultural Revolution struck in 1966 and dreaming of laying down his sometimes wearisome brushes to become a movie director, the prohibition of art during his confinement kindled a restoration of his earlier fervor for painting. Today, he roots around his living room for a tiny precious landscape on paper he managed to paint on the sly during his *xiafang* years . It is a humble effort, palm-sized and inconsequential next to even the paint sketches he does before starting a full-sized painting today (which actually are quite remarkable) but he holds it like a treasure.

It was a legacy of his extraordinary talents which limited Zhang's years of farm labor during this strenuous decade to four. His student work left behind at his old school was noticed during an effort to add younger artists to the staff of old masters at the Beijing Art Institute. Although initially delighted at having been "drafted" to join the working artists who created paintings at the academy, Zhang describes the following years as "very weird." The Cultural Revolution was continuing and the frenzy to destroy the "old ways" led to an historically unparalleled spree of destruction as the Red Guards rampaged through the land. The victims of the roiling repressions which clutched at each province went largely uncounted

and the violent power struggles of clashing factions were played out against a cultural atmosphere that found the most useful values of art in the glorification of communist party triumphs and the exaltation of beatified politicos in a stratified cult of personalities.

As an illustration of why his prized employment as a professional painter, rather than as an art editor or teacher or designer, was less than enjoyable, Zhang cites the Tiananmen Square incident of April, 1976, when thousands gathered to mourn the death of Zhou Enlai with poems and statements that celebrated the fallen leader's modifying influence on hard line communist rule. Authorities, perceiving the tone of the demonstrations to be critical of the less liberal remaining leadership, sent in troops to disperse the "counter-revolutionary" protest with a brutal, club-swinging display of force.

Zhang was among the demonstrators against the excesses of the Cultural Revolution in that crowd and he was further horrified by the orders he received upon his return to the academy.

"We hated the government by then because of their hard, bloody tactics and I was a 'troublemaker' at that event," Zhang recalled. "But when I came back to the academy, my job was to show how the government had successfully pushed down the 'anti-revolutionar-ies.' I don't want to do it but I cannot say 'no' and I have started to hate being an artist. You feel art has turned into a lie. It has become something which is not from the heart and you ask 'so, why do we have art?' and, by that time, my heart almost died. I was saying to myself that I have chosen the wrong profession. I should have been an engineer or a doctor so I wouldn't have to lie. I would not have to do this kind of thing."

The Tiananmen Square Incident of 1976, however, *did* have a rippling effect on the leadership and through the country and the eastern skies began to lighten on the long night of the Cultural Revolution. As an artist, Zhang was one of the early rebels to speak out in his own unique fashion.

"Later, I would tell people that I was not such a brave man, shouting when the night was still dark," Zhang said. "I was already against this government but an artist could not express that. Here, you may say that you hate the President without getting thrown into jail but, in China, if you say 'I hate Chairman Mao!', you will be killed–immediately.

"What I did was, when the time came, when the sun was rising, I felt I must speak out. Most people were not writing. The young people were in the same situation as me, of the same heart, and they have the courage but they are not educated."

The closing of the schools in 1966 had disarmed the intellectual instincts of many and the older, educated people who may have felt the same way, Zhang notes, even the great artists who taught him and worked with him were "numbed" by events.

"They were hardened," he said. "The Cultural Revolution hurt them so deeply that people were still in a stunned state. They could not speak out. When you're silenced for so long, you don't know how to speak. They want to but they don't know how."

Zhang had only his education in art to serve as a platform for his voice and with it he created a painting that recalled an interior of one of the shacks that workers were crowded into to sleep during the *xiafang* captivity. Titled "We Were Young Then ," it became a founding piece in what became known as the "Scar Movement" in Chinese art, an ingenious dropping of the cultural blindfold that would view candidly the circumstances and suffering of the preceding years.

"This painting made a big splash in China and the reason was that, for a long time, people in China were used to seeing paintings that always showed a passive happy face, smiling in the sunshine as Chairman Mao led our summer revolution to victory. I wanted to finally show something of the truth of what happened to us because I went back to the countryside where I spent four years to see what it looked like. Our camp was totally gone– the very small mud brick room, a quarter or a third of this living room, with ten people sleeping. The clay was all melted and grass had grown over it. There was nothing.

"I sat crying, remembering all the troubles, all the love, all the dreams– every pure heart buried there and I decided that I needed to do a painting to show China and the world that the people remember what happened to us. We were very young and we were supposed to have an education and love and art but we were locked there to hard labor for four years and not only us, all over China– my brother-in-law spent eight years in the same situation. So, when the painting was shown in a museum, it was shocking to see the truth and people were weeping in front of it."

"Many people of my generation said 'finally, someone is speaking the truth about what happened to us' and the name 'the scarred' was used because we had been wounded, hurt in our family and we cannot forget that," Zhang continued. "We *want* to remember what happened to us. We want to show people what happened to us, to display our scars. It encouraged the young artist to speak out, to talk about the truth of what happened. It became a nationwide movement as a lot of artists started doing that and a lot of good art came out of it."

A few finger strokes on the laptop resting on the coffee table before us bring another striking scene to the screen. Edged toward surrealism, the dark and chilling images conspire together to conjure a deeply effective story. Although Zhang expresses some reservation about the technical proficiency of the style in this painting, simply titled "No", it's obviously an early personal favorite if only because of the stark message it so powerfully conveys.

"This woman was one of the few people who spoke out honestly against the Cultural Revolution," Zhang explains. "She is a very serious lady, a violinist and a member of the Communist Party and she said that the Cultural Revolution was wrong, we shouldn't be doing this; Chairman Mao has made a mistake.

"So, they arrested her but, because her background was so perfect for them– she joined the army when she was young, she's loyal to Chairman Mao and she's a very popular person– they hope that they don't have to kill her. They say 'You change your mind and we'll send you home, so you can reunite with your children and with your old mother. We don't want to kill you.' But she's so honest, she just says 'No, I'm right and you're wrong. There's no need to send me home. Just do what you want to do.' So, they killed her... They not only shot her dead but, afraid that she would speak out on the way to the execution, they cut her throat to take her voice."

Zhang said that he chose the simple word "No" for a title because it is so shocking, when people speak out against their government, that you can pay with your life for just a simple "no." He portrays her as a "lonely voice in the endless darkness" and as he gestures to the features of the canvas, he notes that only the wide part of the ocean bed is visible while "the night is dark and the sky is crying..."

Collected by the Chinese National Museum, along with "We Were Young Then," as important historical moments in the art movement, some credited Zhang with the invention of a new style. In

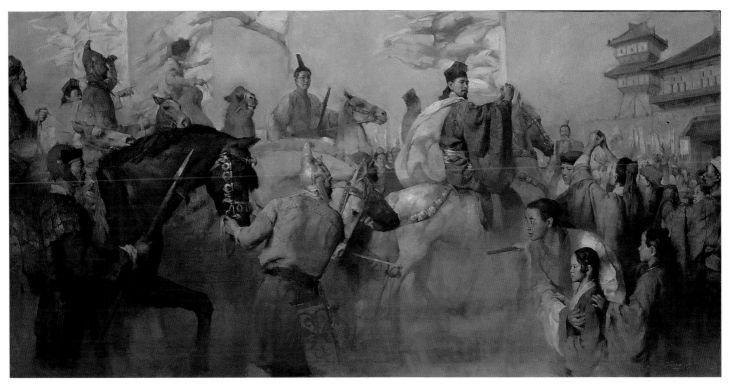

Return of Zhang Qian 36" x 72" Oil

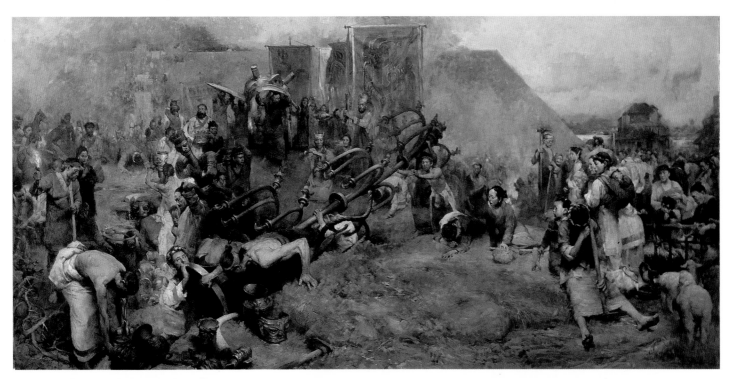

Last Rites (San Xing Dui) 48" x 96" Oil

an American book on new Chinese painting issued many years later, the style is identified as "flashback", suggesting techniques better known in the motion picture field.

"Traditionally, in China, the painting is in the same moment, from the same angle, with the same lighting but I couldn't use that kind of language here," Zhang explains. "I was working from such a shocked and confused stance that the images came almost by accident. It was just everything I was feeling. I feel she's lonely. I feel her daughter is missing her. For me, she is a saint, and so the suggestion of a halo. And people feel the same. I just did what came upon me, breaking all the rules– of the perspective, the lighting, everything– I wasn't afraid to go there and they spoke of having created a new 'stream of consciousness' style..."

What they were calling it or who was following in the art world was of little consequence to Zhang at the time, entangled as he was with following his heart in the new activism of the late 1970s. But there came a point which he equates with a recent documentary movie about Bob Dylan.

"He was leading a movement and suddenly he was tired. He didn't want to do that anymore," a chuckling Zhang said of the young songwriter. "I had the same feeling. I thought of what I had done and wondered how long one should go on crying. I was facing a new life and felt that artists should not always be political. Life is not all politics. I was feeling that every year I should do a new thing. So, I sort of got into a different style..."

Returning from another room with a canvas containing a circus of somewhat brasher images and colors in a vaguely Picasso-

Gauguin combination of forms, Zhang spoke of his "almost destiny" excursions which recalled the earthy blends of color he absorbed while living close to the land, infusing a traditional Chinese sense of colors into a more modern sensibility. Many found this sudden turn odd but writers in magazines that published the work found cause for praise. An influence from Zhang's work in this period may be observed in a later generation's directions but soon the still young master would be off into other flavors of expression.

A more lasting change came with a visit to Tibet.

Renewed Perspective

"When I created those styles, at first it was from the heart but the more I did it, the more I began to wonder if I was just trying to be a leader; to be *avant garde*," he reflected. "Did I just want to create something so that people would say I'm *so creative*? It didn't feel very natural in my personality. Striving for fame is distant from following an artist's heart. So, when I went to Tibet, I found myself feeling very different because the Tibetan people– for hundreds, maybe thousands of years– have been living the same life. They have no thoughts to be famous or how to be rich. They just keep on so natural and so spiritual...

"I say 'spiritual' because they don't think about material things in the false sense that 'fame' is material. They live, give birth to their children, they age and die in their natural cycle. I instantly felt that I loved the kind of peace that they carried with them because my heart had been so busy with the stresses of the Cultural Revolution– fight, fight and fight back. Then, be famous and be a success and all of that. What was the meaning of it?"

Like a receding tide, the impulse to innovation ebbed as Zhang recognized a deeper need to slowly and naturally express his own experiences. Watching Tibetan children brought him back to his own childhood and refreshed the path through long years of training to be able to reproduce what he saw. He found in these mountain people and their humble lifestyles, a surviving echo of the simple joy and positive attitudes that had distinguished his character as a boy. As he sketched in the villages and on the hillsides, he felt a reborn appreciation of life seeping back into his outlook.

During this process of self-examination, Zhang thought about obtaining higher education for himself. If things returned to normal in China in the future and he was asked about his education, he could say only that he had achieved a secondary art degree before everything fell apart. There hadn't been time to apply to film school and when he returned to Beijing after his years on the farm, he had missed painting so much that when he finally *could* paint he promptly forgot about film school. Even though he could count among his friends Zhang Yimou (*Raise the Red Lantern*), Chen Kaige (*Farewell My Concubine*) and other Chinese movie makers of his generation, his fantasy of becoming a film director dropped into second place in his ambitions to the achievement of a Masters degree in painting.

The "Harvard" of his homeland, in Zhang's estimation, was the Central Art Academy, which had had no students or oil painting programs for eight years before they suddenly reopened in 1984. Too old to go back to school for a

Peasants from the Earth 30" x 28" Oil

bachelor's degree, Zhang fretted that the Academy, which chose only five students from all of China, wouldn't consider him at all. Fortunately, however, his ten years of active art experience in Beijing gained him educational credit equal to a bachelors and he was accepted even though his required English proficiency didn't pass muster in the entrance exams. By virtue of his extraordinary talents, they decided they wanted him regardless of these shortcomings and Zhang became one of the five honored students.

"The funny thing is that I started to have the crazy idea that I wanted to come to America," Zhang smiled. "My friends who had gone there early and came back told me I should go because 'you'll really learn and there is great opportunity!' Oil painting has a short history in China' and I was startled when I saw the original paintings of a collection of European art that finally came to our museums. I wanted to learn from those masters because– sure, they have died, but their paintings are in Western museums and we do not have those kinds of collections here.

"I thought I should at least go to look but also I was worried about the art movement in China, which is kind of conservative, and what was going on in the whole outside world. What is modern art? I really wanted to know. The bad memories of the Cultural Revolution were also a shadow in my heart that made me want to see a free country. My family had missed the boat 38 years before but now there was an opportunity for me to go, so I applied at City College (in New York) because it would be impossible in America at a greater school without a bachelors degree. But I *was* in the program at the Central Art Academy, which was very respected internationally and I can use a student visa. Even my poor English is overlooked again."

Zhang's teachers at City College were all abstract painters and somewhat awed by his talents. Noting that he could teach at the school himself, they asked why he had come to study and he explained that the student visa was his best ticket to the United States and that, truly, he did come to learn something he didn't know because the kind of abstract painting they taught could not be studied in China.

Feeling that he had the respect of his instructors as a knowledgeable student and was receiving their best efforts to convey the principles of abstraction to him, he counted himself as extremely fortunate.

"In China, you learn a realistic style of representation," he said. "You look at something real– in anatomy, in perspective, in color, in shape, in form, in lighting; everything to make it look real. But those teachers in New York showed me the dynamics of movement, taught me the abstract qualities, the push and pull; all of those kinds of things, giving me an opportunity to combine them together."

It was at this juncture that Zhang's hidden dragons began to breathe upon his canvas. He brings a recent painting to the screen of the laptop to reveal the subtle beast.

"When I think about my painting, I think abstract first. Most of my compositions start there because I check my movement. Even this one. You feel this is probably realism, right?" he asks, tracing a finger around the arrangement of figures on the screen. "But, actually, this is light movement, see? This is light movement," he repeats each time he points to a different section of the painting. "It's my dragon! This is the hiding dragon, here and here and here. They actually put the painting together because they are not just individual

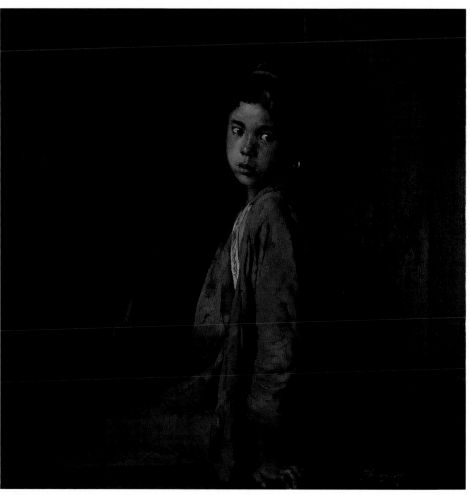

Homage to Vermeer 30" x 30" Oil

objects. They're actually linked together by the movement of the light!"

With only slightly concealed delight, Zhang demonstrates the interrelationships of portions of the scene in another painting.

"It is very intricate, especially in these multi-figure paintings but you don't feel confused with so many figures because I started the movement here and it carries– you can see the shape– going here, this kid, this lady," he continues, pointing out the movements he speaks of as he follows the flow, "going down here to down here and going up with this line and actually down again right here– see this spot?– and down to this and up into this big white... That's my dragon!"

These are the things, these forceful projections of the gaze, that Zhang says he could not learn in China. It exists in some Chinese painting but it is not taught in Chinese comprehensions of oil painting, which he notes is all about creating a realism of objects and figures. That is one reason he later devoted a book, written with his wife and fellow artist, Lois Woolley, to these sensibilities of balance

and motion called *The Yin/Yang of Painting* (Watson-Guptill, 2000). The yin and yang of the book's contents can be found in layers deep enough to enthrall advanced painters while remaining assessable to novices. Beyond those often hard-to-find qualities, it also serves as a superb field guide for dragon hunters.

"This gets into the abstract thinking of how the yin and yang are offset to each other but, at the same time, are working to each other," Zhang said. "The movement from up going to down; from left to the right and, this way– right to left– all of it like yin and yang; warm and cold; dark and light; sharp edges and soft edges; thinner layers and thick layers; transparent layers and opaque layers– all working together, in yin and yang– it's a whole oil painting."

A New World

Due to difficulty with the legalities of American currency in China that he finds challenging to explain, Hongnian Zhang arrived in New York to start his student life there with $30 in his pocket. As might be expected, times were tough and Zhang had to rely upon the strength he gathered from his years in the countryside. Shocked, lonely and confused in the bustle of an alien city, Zhang found the determination to paint his way into this new landscape. He found a friend willing to lend him money and, sorely conscious that it was not his own money he was surviving with, he pinched and saved every penny, walking the miles each day between the campus on 110th Street to Chinatown to save 85 cents on a subway token. He ate only peanut butter, bread and orange juice– nothing else.

"Of course, I worried always, how can I find my life here," Zhang said. "But my landlord was a friend who asked me to stay with him because his wife was teaching in China. He said he would charge me $200 and I exploded 'What!?' but I was naïve and this was such a good offer– $200 to stay in Manhattan! I didn't know how hard it was to make a living here. But he helped me. He put a note in the elevator that said 'Famous Chinese artist has come here and can do a sketch for $15 each.' I got jobs like a father holding his baby and a group of musicians rehearsing in the basement who asked me to do a sketch. Things like that."

Zhang speaks of an artist friend, a professor in a Brooklyn technical college, whose work sold less than briskly in New York even though his paintings were excellent.

"He wanted to know why I came to America when I could have stayed in China and gotten paid as an artist. 'You're famous. You can do your great art and not worry about it. Why did you come here?' he said. Like others, he doesn't think I can make it here and I don't know either. I just want to try."

Sometimes, Zhang muses, it's good luck. That is important, he believes. It was a stroke of good fortune which brought him into contact with one of New York's most respected art galleries, through his acquaintance with the noted sculptor, Wang Jida.

An "Overnight Success" Finds Morning

A graduate of the Central Academy of Fine Arts, Wang Jida's abilities were tapped when the Mao Zedong Memorial Hall was constructed in Beijing in 1977. After his arrival in the United States in 1983, he was selected by the Century Memorial Foundation of the Statue of Liberty and Ellis Island Foundation to create a small scale model of the world renowned statue for its centennial celebration in 1986. The story of a sculptor who had worked on Mao's monumental structure creating a commemorative replica of the Statue of Liberty caught the fancy of the press and the notice of the highly regarded Grand Central Art Gallery in Manhattan.

Zhang's acquaintance with Wang Jida at this time brought him and several other Chinese artists into the spotlight. James Cox, director of the Grand Central Gallery at the time and now owner of his own gallery in Woodstock, recalls the excitement generated by the discovery of this unsuspected stream of work.

"It was historically significant to find these artists together in New York at that time," Cox recalls. "Chinese realists painting with oil on canvas! We were just amazed by it and anxious to find out how this happened. I was drunk with questions– where did you come from? How did you learn this? Who were your teachers? We spent lots of time together just laying the groundwork for what we were looking at and who these people were. The strongest similarity to their work that we could find was the great Russian artists and the American painters of western New Mexico from the Taos school."

Zhang remembers spreading out his unstretched canvases on the floor, with bricks at the corners, when Cox came to view them. When an exhibition was prepared that included his paintings, it marked a dramatic turning point for him.

Literally overnight, the Grand Central Gallery exhibition brought the attention of the vastly influential New York art scene to the unique splendors of Hongnian Zhang's work. There was an article by Milton Esterow in *Art News*, an interview on CBS's popular *Sunday Morning* program and other ripples of interest spread by that initial splash. Suddenly, Zhang found his paintings in such demand that his focus shifted from his studies to making a living with his brushes. Only six months into his courses, Zhang confesses that he devoted scant time to his rapidly executed school assignments but, not surprisingly, they were still of such self-assured quality that his instructors didn't seem to notice how quickly they had been done.

Meanwhile, Zhang's Tibetan themes were flying off the walls and finance was no longer a fearsome concern. He still smiles to tell how he chose to celebrate.

"I suddenly have so much money that I decide I must buy some good food for myself," Zhang remembers. "So, I go to the food store and get a lot of stuff but when I'm on line, ready to pay, I notice that I still have the same three things– peanut butter, bread and orange juice. It was all I knew and even though I now had the money, here I was buying the same things! It was kind of funny."

Returning the loan he received from friends when he arrived, Zhang learned that it had been considered a gift by the donors which he wasn't expected to repay but "No," he explained, "I always knew that was not my money. That is why I was so careful with it."

Before he had quite completed his art studies, Zhang learned of the illness and death of his first wife in China. Realizing that he had to return immediately to bring his young daughter to live with him in the United States, he left school and redesigned his roadmap for the future.

"I didn't want my daughter to grow up in the city, so I needed to move to the country," Zhang explained. "I just basically packed up and moved to Woodstock and, living here, it became important for me to feel that I was not a Chinatown artist– that I'm an American artist. I'm living in America. I'm not speaking Chinese every day. I did not feel that it would be good for my daughter to grow up in a

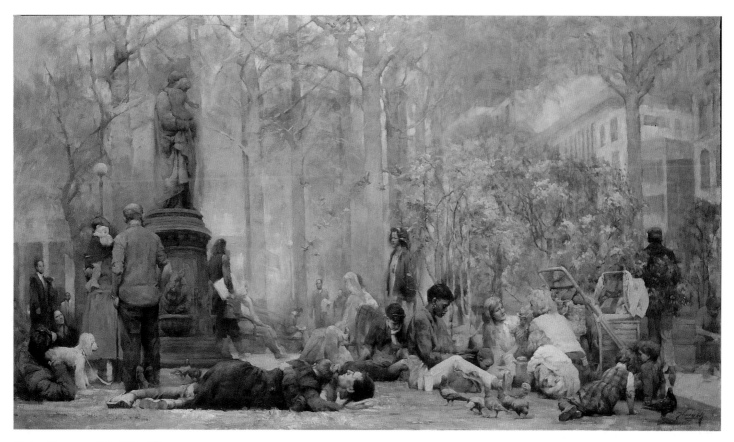

Union Square 40" x 70" Oil

place where Chinese was the daily language and I think that was a good decision. She graduated from high school salutatorian, speaking perfect English, with the second highest grades in the entire school."

Zhang's daughter Renée went on to Brown University, London School of Economics and Thunderbird School of International Management. Yet maintaining her Chinese was always a priority. Throughout her American childhood Renee returned to China each summer to visit family. Today, her dual cultural background serves her career in international business well at her office in Shanghai.

Commissioned by *National Geographic* magazine for a series of paintings on the history of China, Zhang has returned to his original country a number of times to research the ancient dynasties. In his travels, he feels he retains an American identity now, wherever he goes. He sees commercial galleries in China today, selling new art work where, not long ago, galleries and museums were only for "show." He notes the current popularity of installation art in Chinese galleries of the new century and a steady expansion of the forms of art found acceptable to a Chinese audience. But with Lois Woolley, now in his life and the Woodstock artist community offering creative companionship, Zhang recognizes his place is now rooted in a new land. Increasingly, his paintings reflect American themes...Union Square and other scenes of New York City, trick-or-treaters on a Woodstock street, the lives of the pilgrim settlers of New England which reminds him of his own pilgrimage.

"I feel my heart really understands how life is difficult to start in a strange land," Hongnian Zhang says, gazing toward the window as a painting of two pilgrim women gleams on the laptop screen. "I will just keep going where my heart takes me. Today, I like being an American artist. I feel American."

—*G. Alexander Irving*

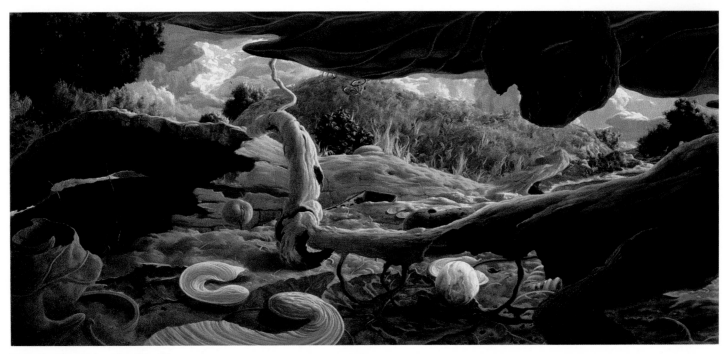

Tornado Alley Sink 9" x 19" Oil

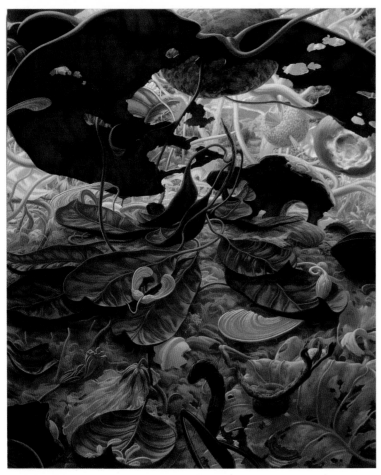

Trenton Summer 16.5" x 19.5" Oil

JAMES V. FREEMAN

The artist graduated Magna Cum Laude from The Savannah College of Art and Design. Born in Peoria, Il. In 1969, he has been active in the art community since moving to the Delaware Valley from Chicago in 1999. In 2002 he was included in Doris Brandes' book, "Artists of the River Towns."

Among many honors, he was included in New American Paintings, Vol. 63, Juried Exhibition in Print in 2006; won First prize at the 43rd Annual Open Art Award Exhibit at the Lancaster Museum of Art, Lancaster, Pa.; Best in Show at 22nd Annual Ellarslie Open, Trenton City Museum, Trenton, N.J., curated by Petra ten-Doesschate, and had a solo show at Radclyffe Gallery in Lahaska, Pa. He has recently won the Grand Prize from International Artist Magazine, Issue #50, in the "My Favorite Subject" competition. Mr. Freeman often gives slide lectures to the public at arts and educational organizations.

Visions of intertwined landscapes and objects mesmerize with a playful distortion of scale by combining tiny, up-close objects with middle-ground and distant scenery. Images are composed from memory in a way that is at once abstract and sculpturally realistic. The viewer sees the goal of the image before visually stepping into the spatial landscape.

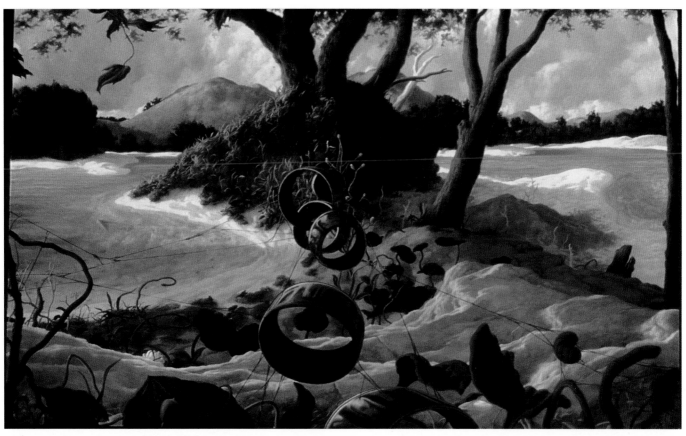

From the Spiderwebs 10.25" x 16.25" Oil

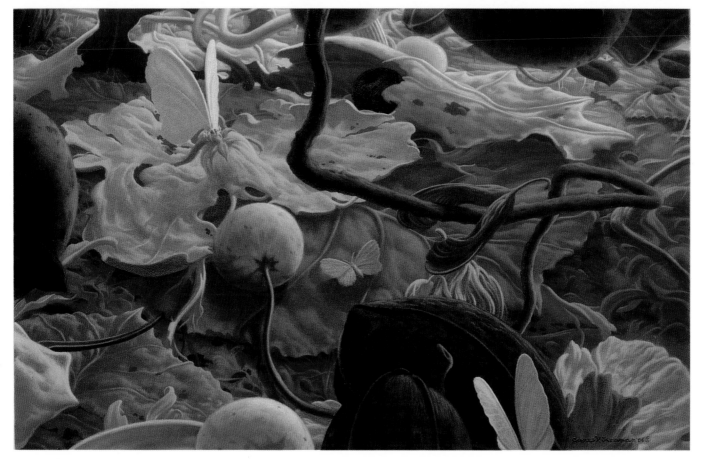

Trenton Summer 2 10" x 6.5" Oil

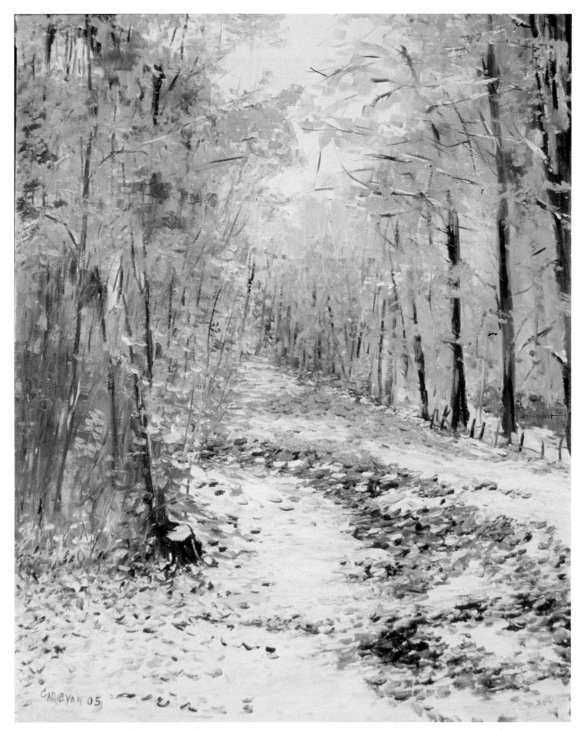

First Snow 22" x 18" Oil on canvas

BORIS GARIBYAN

Memories of his youth by the Caspian Sea in the former Soviet Union, where he was born in 1953, result in Boris Garibyan's penchant for seascapes and landscapes. Garibyan has maintained this theme in his work since he moved the U.S. in 1991. He paints *en plein air* or in the studio in Idaho, his adoptive home. While creating his own style, the artist was influenced by the Impressionists and by his father, who was an artist. He participates in local art exhibitions.

My work reflects my passion for painting, color and nature itself.

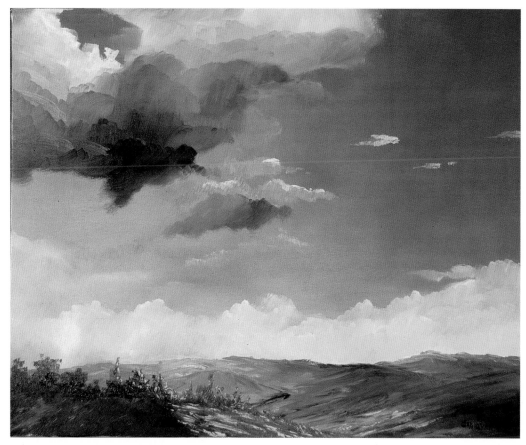

Rain Clouds 18" x 24" Oil on canvas

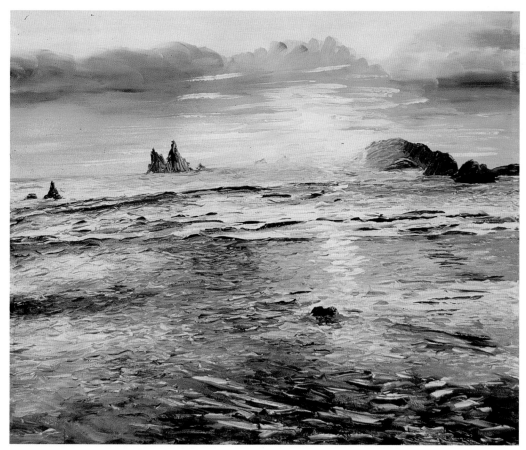

Pacific Romance 15" x 24" Oil on canvas

Just Call Me Madame 12" x 10" Acrylic

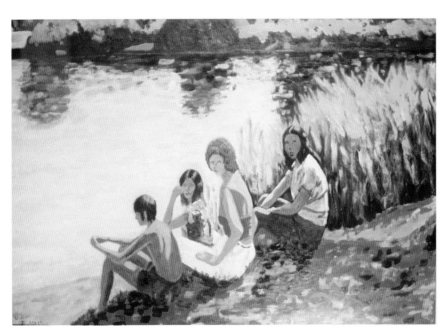

The Pause That Refreshes 25" x 32" Acrylic

ESTHER AKRISH

In 1981 Esther Akrishthem earned a B.F.A. in Painting from the University of Washington, where she studied with professors such as Jacob Lawrence, Spencer Mosley, and Michael Stafford.

The artist has won numerous awards, including Honorable Mention in the 2004 Kenmore Art Show; an award for Painting in the Renton Annual Art Show, also in 2004; and the Washington State Potato Commission Purchase Award for her painting "The Potato Peeler," at the Moses Lake Museum and Art Center. Subject matter includes the figure, landscapes and still life, using oils, pastels, acrylics, or watercolors.

Her work has been shown at the Salmagundi Club National Society of Painters in Casein and Acrylics in New York City in 2000 and 2005, at the San Diego Watercolor Society International Exhibition in 2001, RIWS in Pawtucket, Rhode Island in 2001 and 2003, and many other venues.

I strive for originality in my work by heightening and exaggerating the design, form, and color and using them in an expressive manner. This allows me the freedom to explore and to create a more visually exciting body of work. My aim is to bring forth an emotional response from the viewing public. If this has been accomplished, then I have succeeded well.

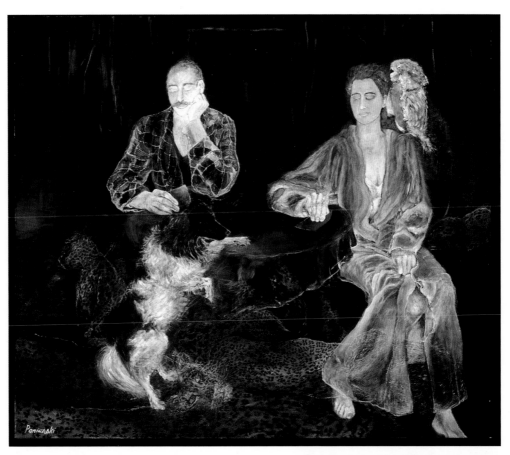

Who's Game #3 48" x 56" Acrylic

RUTH PONIARSKI

Ruth Poniarski began painting in 1988, after completing a degree in Architecture in 1981 at Pratt Institute in Brooklyn, N.Y. She worked as an architect in the New York City area, and also studied abroad, in Europe and the Middle East. Her work draws from a wealth of sources, including cultural references, myths, art history and the contemporary world.

Her art has been exhibited at the Silvermine Guild, Connecticut; Parrish Museum, Southhampton, N.Y.; Holter Museum, Helena Montana; Trevi Flash Art Museum, Trevi, Italy and most recently at a solo show at Karpeles Museum, Newburgh, N.Y. Ms. Poniarski exhibits on a yearly basis at the Amsterdam Whitney Gallery in New York City. Her work can also be found in private and public collections in Maryland, New Jersey, Manhattan and Long Island, N.Y.

I like to quote the Old Masters, inserting a detail or a figure from Leonardo or Botticelli in my compositions, much as one would include an old friend or family member. The context is always surprising and always involves an element of metamorphosis.

Dream 48" x 58" Acrylic

Private Moment 36" x 42" Acrylic

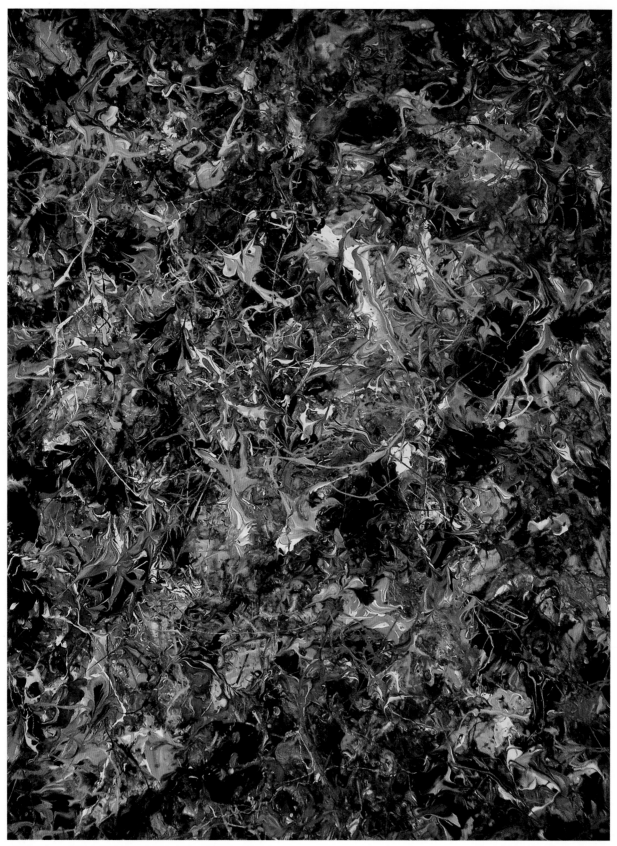

Gateway 16" x 20" Lustre print

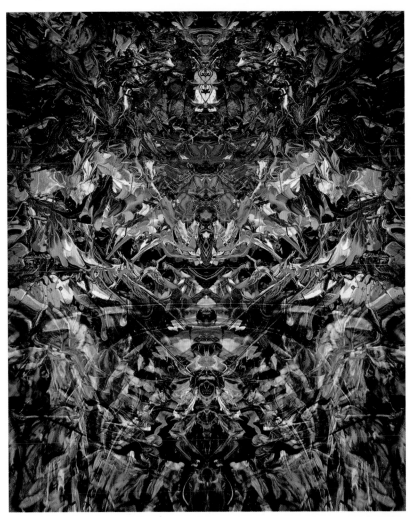

Into the Unknown 16" x 20" Lustre print

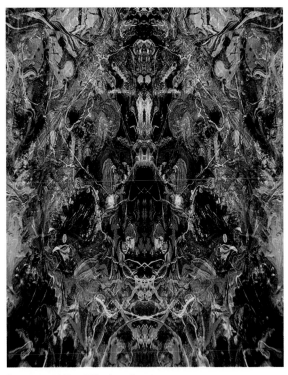

Sunyata 16" x 20" Acrylic on canvas

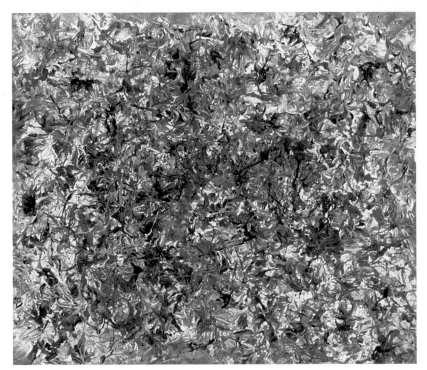

Extending Inward 20" x 26" Acrylic on canvas

BEN DREWRY

An abstract artist working in various mediums including paint, digital art and video, Ben Drewry has presented and published the article, *Art Attention and Consciousness: An Experiment in Experimental Painting* at an international conference sponsored by the Planetary Collegium in 2005. Drewry was born in Hollywood Florida, November 21, 1981, and resides in Lexington, Ky. Presently, he is studying art at the University of Kentucky, and his work is featured at several galleries in that State, including the Carnegie Center.

I am attempting to extend the painting process beyond the canvass into digital and print mediums in a creative and direct manner. Rather than using digital technology to reproduce painted works, I use it to expand the perceptual experience of the painting directly as a continuation of its essential nature....

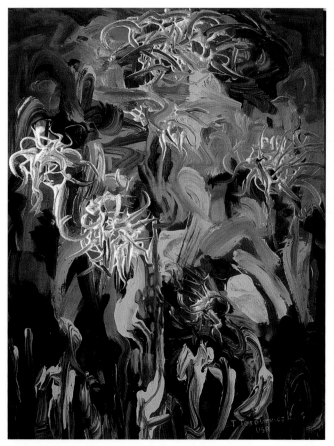

Dandelions 36" x 28" Acrylic on canvas

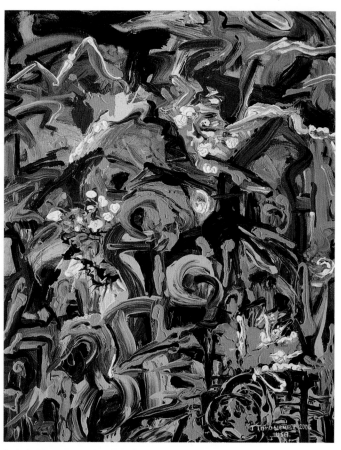

Baby's Breath 36" x 28" Acrylic on canvas

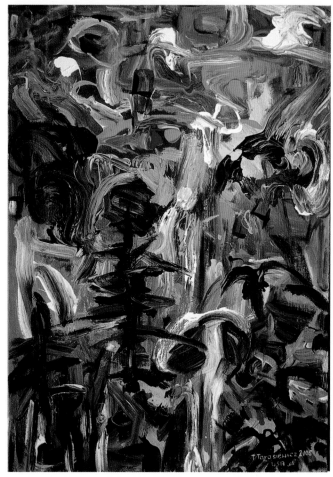

Mountain Illusion 36" x 28" Acrylic on canvas

TAMARA TARASIEWICZ

A native of Poland, Tamara Tarasiewicz has received awards from the U.S. government for her contribution to American culture. She is inspired by worldly observations of nature's presence in rural and urban life. Her work is marked by color and a sense of movement.

I am always in pursuit of impact value in my paintings, whether it is the style of the brush stroke or the color palette. I gather beauty from nature and enrich it with my own emotions, expressions and explorations of painting gesture. My work reflects a fascination with life and the unexpected activities that occur.

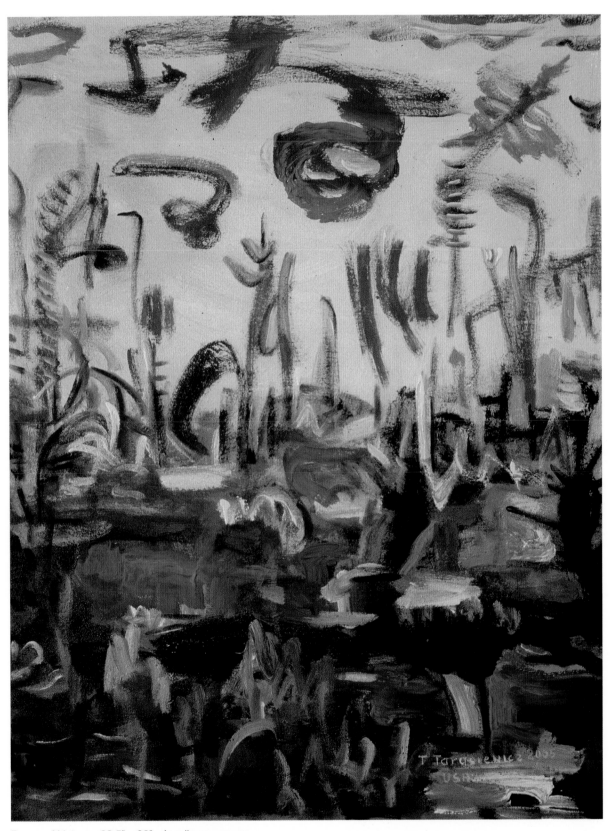

Power of Nature 39.5" x 28" Acrylic on canvas

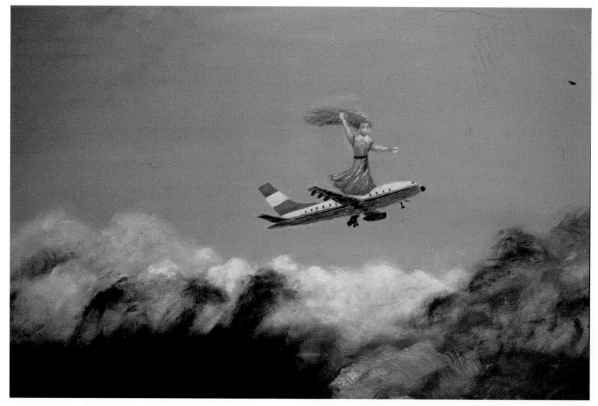

No. 91 Feeling Free 30" x 40" Oil on canvas

No. 96 Midnight Ballet 24" x 30" Oil on canvas

No. 57 Dusk Landing 30" x 40" Oil on canvas

HELGA SCHWEININGER

The natural Austrian countryside where Helga Schweininger grew up inspired her love of art. In 1963, she moved to Southern California, where she still resides with her husband. She attended Laurie Werner's Art Program in Orange County, learning from many people and by studying old and new masters. Her work has won awards from the Irvine Fine Arts Center, the Dana Niguel Arts Council, and the City of Newport Beach, California.

I see an artistic bridge between all people of this world. I regard art as a bridge for peace.

Seal Family 18" x 24" Watercolor

2 Bats Eating Figs 18" x 12" Watercolor

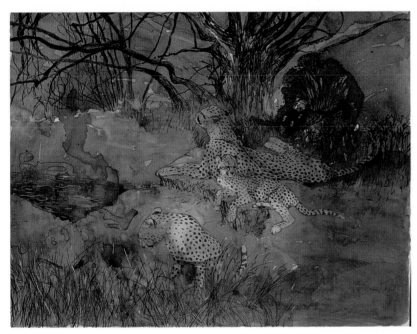

Cheetah Family 18" x 24" Watercolor

NAOKO OSHIMA

Naoko Oshima was born in Tokyo and attended a high school in Kyoto, Japan where arts and crafts were taught extensively. She earned a BFA from Tama Art University in Tokyo in 1986, and came to New York City to attend the Art Students League in 1992. Her teachers included Peter Cox, Harvey Dinnerstein, Ronald Sherr and Mary Beth McKenzie. In 1996, Oshima started to work in watercolor. Her work has been exhibited in Tokyo, New York and throughout the U.S. Both her oils and watercolors are in many private collections.

I don't know if art alone can be a voice to raise awareness among people, and the purpose of art is not only to make a political or social statement, but at least I make art out of necessity to deal with what is true to myself and how I relate that to the world I live in.

Eve: The Consequence of Truth 16" x 20" Oil on board

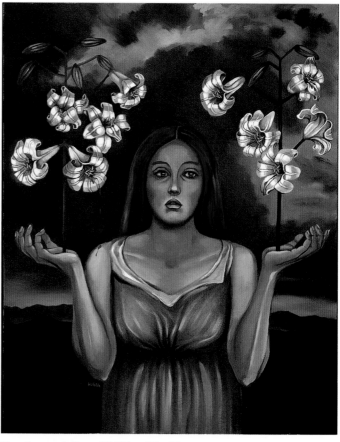

Eve: Annunciation 32.25" x 40" Oil on canvas

Eve: Oral Tradition 16" x 20" Oil on board

EMILY HOGAN

Emily Hogan works out of her home studio in
New Orleans. Born in Shreveport, Louisiana, she
graduated from Tulane University and earned
her MFA in painting from the Savannah College
of Art and Design. Her work is exhibited at
Montserrat Gallery in New York City, the Poet's
Gallery in New Orleans, Gallery 119 in Jackson
Mississippi, and the LFIA Gallery in Ponchatoula,
Louisiana. She has participated in numerous
juried exhibitions throughout the U.S. and in the
British West Indies.

*My paintings tell stories based on my
experience, and are carefully constructed
using a lexicon of symbols—some personal,
some universal. They allude to traditions that
inform the way I conceive gender relations,
society, and spirituality.*

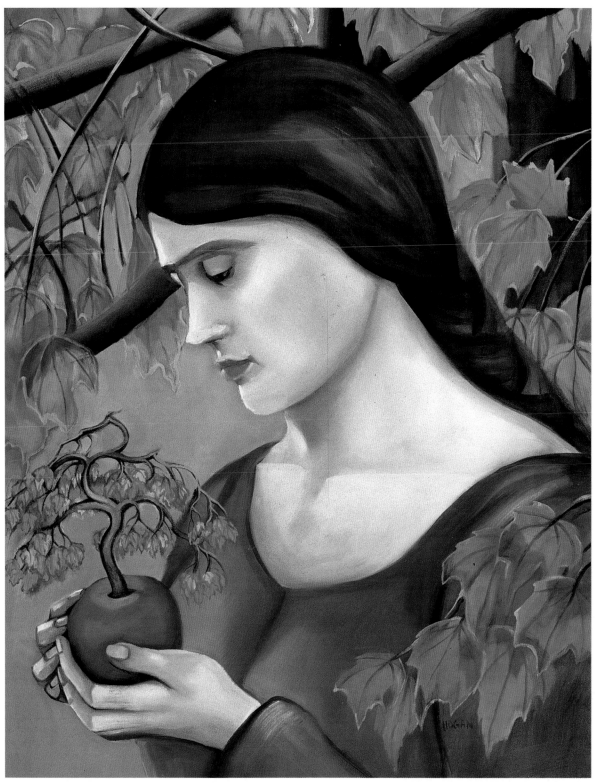

Eve: What Is This That I Have Done 16" x 20" Oil on board

Golf Course 17" x 20" Oil on canvas

Yellow Sky 18" x 24" Oil on canvas

Garden City 16" x 18" Oil on canvas

MICHELLE SAKHAI

Michelle Sakhai earned a B.A. degree with High Honors from Hofstra University. She also attended C.W. Post, New York University, and studied in Venice, Italy. Then, through the School of Visual Arts in New York City, she painted in Spain. Deeply influenced by the Impressionists, Sakhai has depicted Spain *en plein air* from the streets of Barcelona to Valencia.

She is affiliated with the Nassau County Museum of Fine Art, and currently resides in Long Island, N.Y.

Before I paint, I spend time just allowing myself to absorb and feel what is in front of me. My objective is to observe nature at once, yet in its entirely. This particular moment is of great consequence to the end result of my painting.

Cades Cove, Great Smoky Mountains 24" x 36" Acrylic

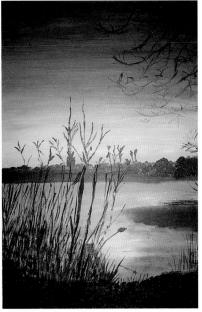

Panorama of Swiss Alps 24" x 36" Acrylic

Lake Gonno, Italy 36" x 24" Acrylic

ESTHER FLINT

Esther Flint discovered painting recently, having enjoyed a successful career as an opera singer and language specialist. She graduated from Brooklyn College with highest honors in Hebrew and went on to earn a MFA in music from New York University. She hadn't taken up art because she is allergic to oil paint. Two summers ago, however, yearning for a new challenge, she discovered acrylics. As a painter, Flint is self-taught. Already, her work has been exhibited at the Amsterdam Whitney and Jain Marinucci galleries in New York City, and was included in the Capitol Arts Network "American Landscapes" Show.

I paint beauty. I love beauty in art, music, literature, nature and loving relationships and friendships. I hope that whoever sees my paintings will be inspired to promote beauty and harmony in the world and among nations and people.

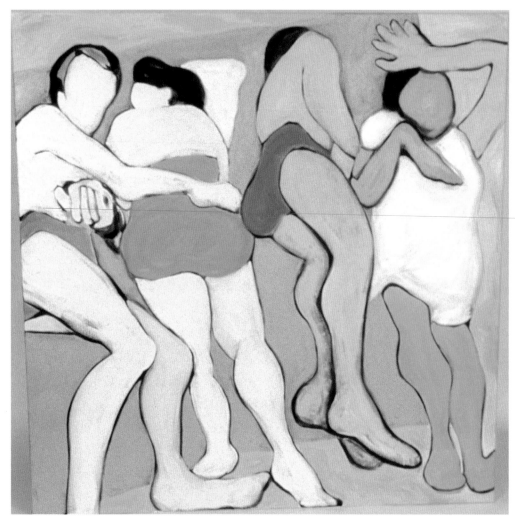

Attachment 36" x 36" Acrylic on canvas

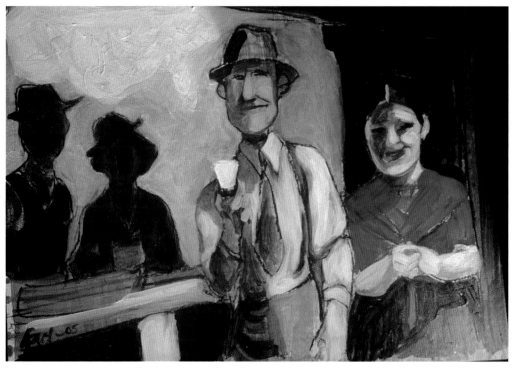

Denied 11" x 14" Acrylic on board

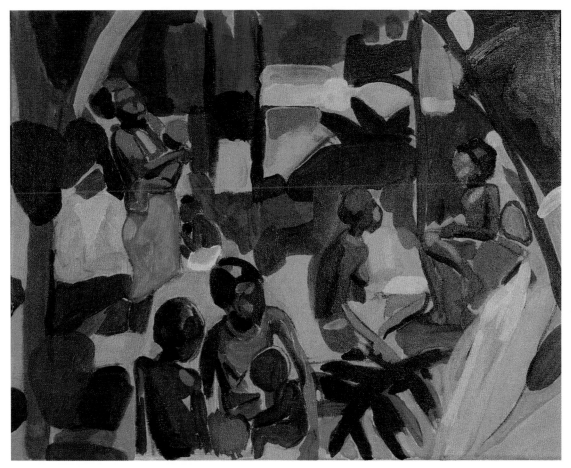

Family Circle, WWII 16" x 20" Acrylic on canvas

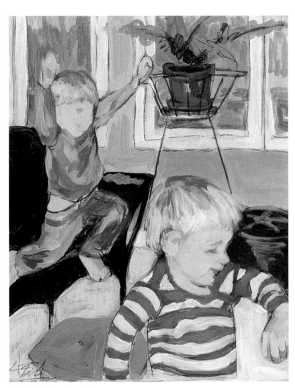

Sunrise 20" x 16" Acrylic on board

ALLYSON NORWOOD BUSH

Allyson Norwood Bush was well-acquainted with adversity before she graduated from the University of Maryland, earned a graduate degree from New York University, worked as an art therapist and as a freelance writer before starting to do what she always wanted to do: create art. Now she brings compassion born of experience to her paintings, which feature people in their everyday lives.

Born in Baltimore in 1965, Bush overcame many personal problems and, as an adult, worked for several years on the Bowery helping mentally ill, homeless adults and people who were living and dying with AIDS. Now she takes care of her family and works with youth while expressing her humanity through painting.

I respond to everyday scenarios in American life and reflect the emotions of isolation that are exposed in relationships. Women are particularly intriguing because they so often seem to trade a sense of authenticity for the security and honor of caring for those around them. My work addresses how the spirit is often locked into roles that may hinder growth. I want the viewer to see something of self, the universality of the human experience.

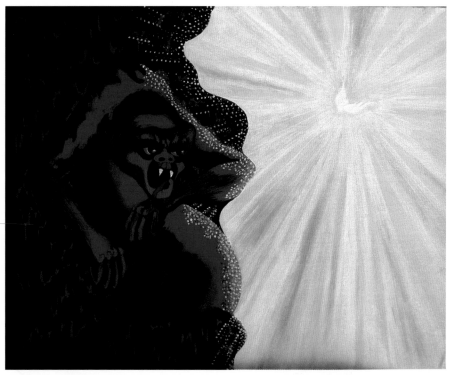

Dark and Light 16" x 20" Oil

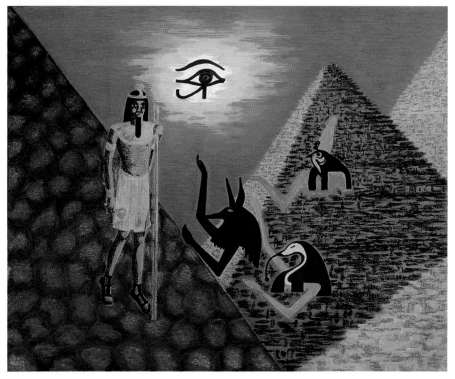

Mystery of Ancient Egypt 16" x 20" Watercolor pastel

TATYANA SHVARTSHKH

Curiosity, energy, courage and intelligence are among the qualities this artist brings to her creations. Born, raised, and educated in Russia, Tatyana Shvartsakh is now immersed in the culture of her adopted country, America, to which she immigrated several years ago with her husband.

Her work is exhibited in the Philadelphia area and she participates in art shows throughout the Northeast. Sharing her inner world is of utmost importance; that's how the artist relates to others in a new land.

I like different mediums to depict my inner world and my view on the truth of entity. In my work, I reflect my thoughts about the complexity of the human soul, about mystery, wisdom, and eternity.

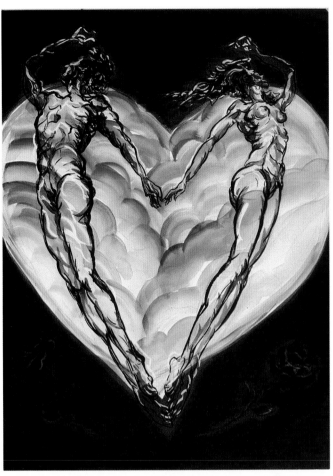

Forever Love 18" x 24" Watercolor

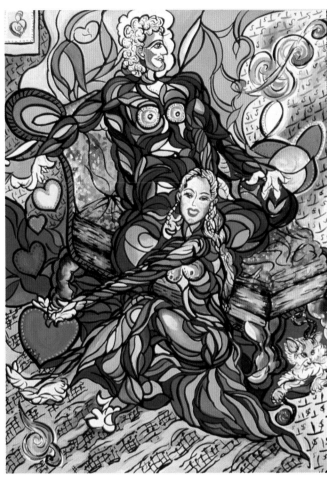

God and his Love 18" x 24" Gouache

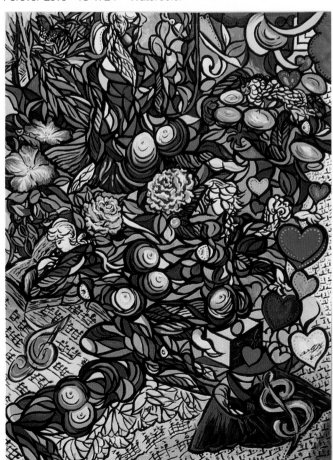

Seeking for Dream 18" x 24" Watercolor

ANNA YUNG

In addition to her career as an artist, Anna Yung is a professional financial trader who witnessed the corporate scandals of the 21st century unfold before her eyes. Deeply moved by the adversity into which employees and clients of corrupt businesses were unjustly plunged, Yung applies her classical watercolor and abstract techniques to create what she calls "Financial Art."

Anna Yung studied at the National Academy School of Fine Arts, the Art Students League of New York, and the Fashion Institute of Technology. Her work is exhibited at the National Academy Museum in New York City, and her work is in private collections.

I strive to be the greatest artist of the century, to create remarkable artwork with strong fundamental techniques, and to represent our generation's historical culture.

Vibráto 25" x 28" Aquamedia

BERNYCE ALPERT WINICK

Bernyce Alpert Winick began studying music at the age of six and art before the age of ten. She received a B.F.A. degree from New York University, and subsequently attended the Brooklyn Museum Art School, Traphagen School of Fashion, Art Students League of New York, and the National Academy of Design School of Fine Art, in addition to private studies with Mario Cooper.

In 1966, after ten years as a Fashion Designer, Winick turned to Aquamedia painting. Her first solo show was held in 1969 at the Hewlett-Woodmere Public Library, Long Island, She has since won numerous awards, including two first prizes at the National Arts Club and three first prizes at the Salmagundi Club, New York.

Her paintings have been exhibited in juried national competitions of the American Watercolor Society, the National Academy of Design, and other prestigious arts organizations. Richard D. Marshall, a curator at the Whitney Museum for 20 years, selected and installed Winick's paintings for her solo exhibit at the Z Gallery in Soho in 1994. Winick also works as a photographer and a classical pianist, and is included in *Who's Who in the World* and *Who's Who in the 21st Century*, Cambridge, England.

From the soaking of the paper to the application of harmonious color in a rhythmic chromatic flow—sometimes serene, sometimes dramatic—I feel an intense energy. Lyrical and gestural, yet sometimes serendipitous and spontaneous, the curvilinear images communicate vitality and excitement from within.

Bríoso 60" x 40" Aquamedia

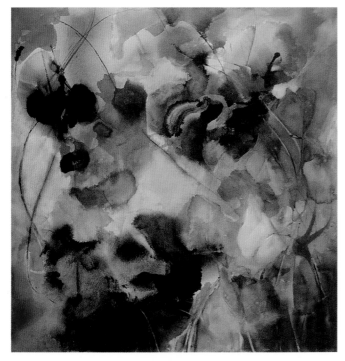

Allegrétto 49" x 44" Aquamedia

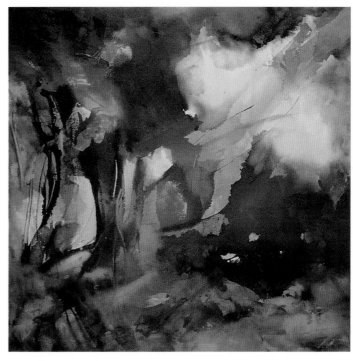

Expressióne 36" x 48" Aquamedia

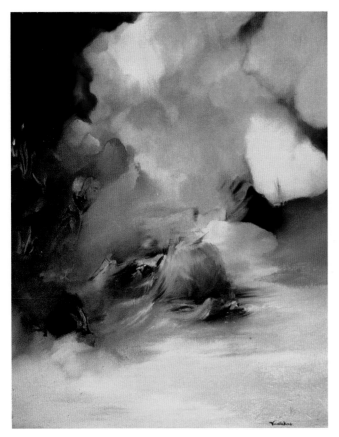

Mindscape 16" x 20" Oil on canvas

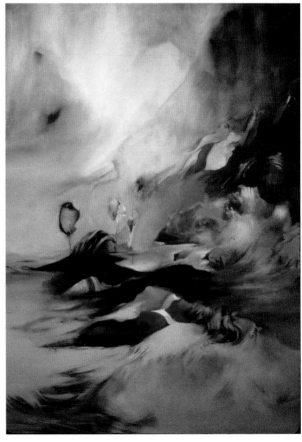

Bridge 36" x 48" Oil on canvas

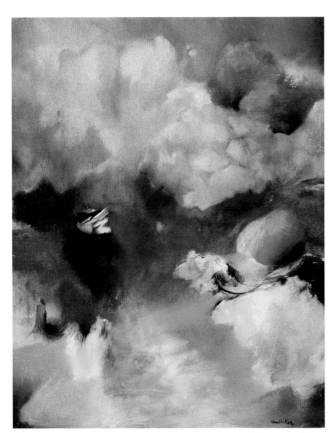

Paradise 16" x 20" Oil on canvas

JENNIFER VASILAKOS

Jennifer Vasilakos creates emotionally charged oil paintings that weave in and out of darkness and light, revealing secret paths in a search for justice. The artist earned a B.F.A. from Florida Atlantic University in 1998, and won a scholarship to study at Studio Arts Center International in Florence, Italy, 1995-96. She participated in the Erasmus Project in Delphi, Greece, which resulted in the exhibition "Le Lumbilico del Mundo", Bologna, Italy, 1996.

Her work is a part of the permanent collection at the Boca Raton Museum of Art, Boca Raton, Florida; has been exhibited Michael Ingbar Gallery, Soho, N.Y., 2001; Yoga Society of New York, Monroe N.Y., 2000; SACI Art Exhibition, Florence, Italy, 1996, and numerous other galleries and museums in the U.S. and abroad. Among her awards are Best in Show ini painting at the 43rd Hortt Memorial Competition in Ft. Lauderdale, Fl., 2002, the Dorst Award, Boca Raton, 1996, and the Artist Recognition Award, Tri-County Exhibition, Coral Springs, Fl.

There is no power stronger than the human ability to use energy. Energy is positive and negative. Once the negative moves back, the positive can move forward, and vice versa. My work is a push and pull of these two concepts. Based on images of all four natural elements needed for human survival, water, air, fire and earth, my works landscape my mind.

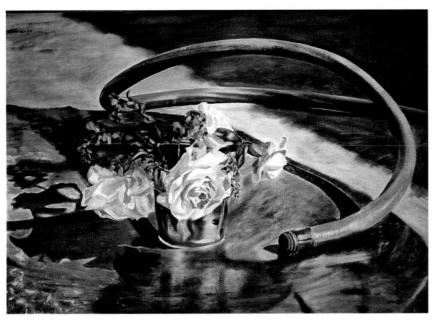

Rose and Hose 3' x 2' Oil on canvas

Whisper and Glow 16" x 24" Oil on canvas

Anticipation 22" x 18" Oil on canvas

IRINA STROUP

Irina Stroup was born, raised and educated in Russia. She studied music and earned a degree in biology before working as a research scientist at Moscow's department of toxicology. Interested in art since childhood, she visited museums throughout Russia, Ukraine and the Baltic Republics, never missing an exhibition at world-famous museums and galleries.

After getting married and moving to the U.S., she studied art at Shasta College in northern California and received her first art award at a juried regional show. Irina Stroup's works are held in private collections.

Like sounds and smells, images and color combinations—or just a sudden play of light—can revive intimate and tenderly cherished associations collected from our past experiences. Art helps to prolong these moments. It allows us to live through them again and again. I wish to master my skills in what I call "sensual impressionism."

Evolution of the Brain 35" x 27" Oil on panel

Love that Red! 48" x 36" Oil on 4 canvasses

ELIZA MARIA SCHMID

A native of post-World War II Austria, Eliza Schmid is psychiatrist who learned to draw anatomy at the University of Vienna medical school. In 1976, she received a fellowship to Stanford University in California, and stayed in America. Her artwork is influenced by her "baroque-Catholic" upbringing, fairytales, and the experience of being a European/American.

Her most recent solo exhibit, "Witches and Transparent People," was at Jadite Galleries in New York City. In 2006 alone, she has had solo exhibits at the Counter Culture Café and several galleries Santa Fe New Mexico, her new hometown, and at Infusion Gallery in Los Angeles.

I could paint stories and ideas for the next hundred years as a result of my adventurous private and professional life.

Melody Over the Lake 36" x 24" Oil

HUMBERTO CHAU

A citizen of the world, Humberto Chau was born in Peru, earned his degree at Zhong Shan University if Guangzhou, China, and now lives in New York City. Recently, he was appointed an Academical Knight by the Accademia Internationale Greci Marino of Rome, Italy. His work has won honors in Stockholm, Sweden, and is exhibited regularly in my fine galleries in the United States.

People's daily lives form his subject matter. From fishermen to ladies at leisure, Chau places people in the favorable light of beautiful surroundings.

Each brush stroke reflects nature and life, with motion and mood influenced by colors, shapes and textures.

The Ballet 14" x 17" Acrylic

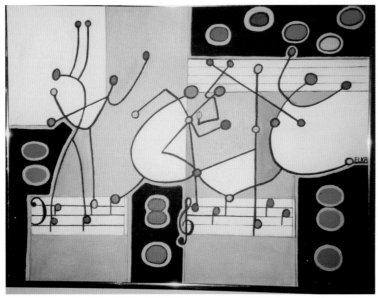

Jazz Dancers 18" x 24" Acrylic

ELIZABETH WILLIAMS

For this dance series I mainly used line to portray movement and sound. I observed my progression from the still life styles of George Braque, then to the abstraction style such as that of Picasso and now to the line abstract style.

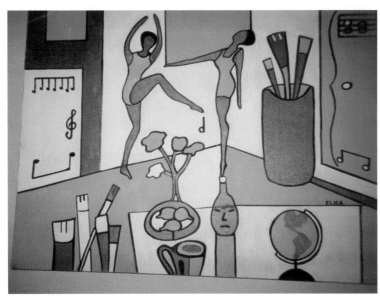

The Studio 18" x 24" Acrylic

Ambigue 18" x 24" Acrylic

Artifaxia 18" x 24" Acrylic

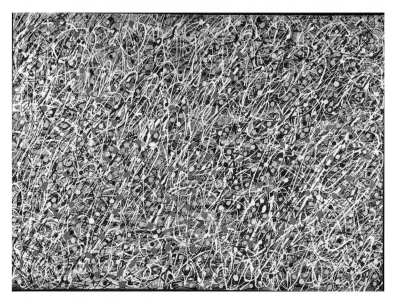

Incipience 26" x 36" Acrylic

CARL RICHARDS

Carl Richards started painting at the age of four. "While rummaging in the basement, he discovered his father's paint cans and painted his own version of 'The Last Supper', which was a big hit at the local Sunday school."

Richards' first solo exhibit appeared in 1968 at Illinois Wesleyan University, and solo shows have occurred regularly since then. His most recent exhibits, in 2005 were at the Center for Creative Leadership, Greensboro, N.C. and the Star Gallery, in Orleans, Ma. He is currently affiliated with several galleries and museums on Cape Cod, including the Cape Cod Art Association, Barnstable, Creative Arts Center in Chatham, Cape Cod Museum of Art in Dennis, Star Gallery in Orleans, and Harvest Gallery in Dennis.

In 2005, Richards participated in the "Art of the Northeast" Exhibit, Silvermine Gallery, New Canaan, Ct. He was featured in the 14th edition of Living Artists in 2005, and studied with Zhang Jing Sheng of the University of Tienjin, China. Among many recent awards, Richards received First Prize for *Les Fleurs Jolie* from the Cape Cod Art Association in 2004; Best Non-Representational, *Stand of Trees in Winter*, Falmouth Artists' Guild in 2003, and Juror's Choice Awards from the Falmouth Artists' Guild in 2004 and 2005.

Art is that journey of the spirit whose Ultimate expression culminates in the abstract. Like the mystery of life, it can be experienced but not explained. Art is not a picture of something, But, like music, is the thing itself.

SADIE YATES

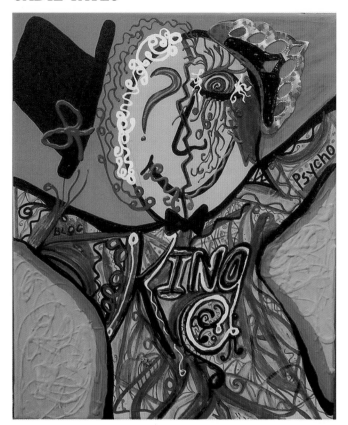

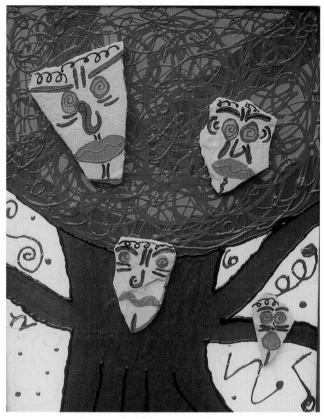

Family Tree 16" x 20" Mixed media on wood

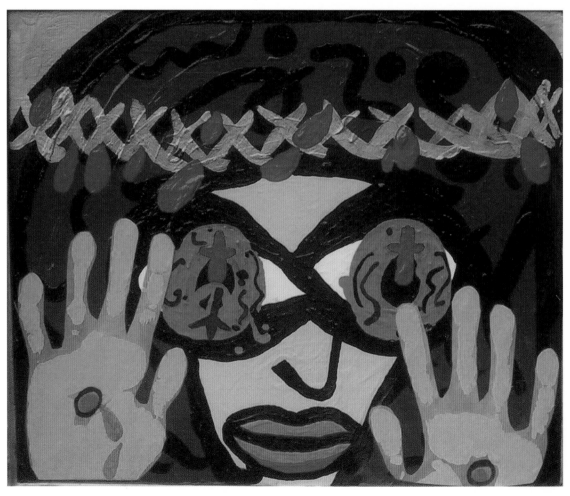

Wide Eyed Jesus 8" x 10" Mixed media on wood

Self Portrait Today 16" x 20" Acrylic on canvas

SADIE YATES

Sadie Yates is motivated by the strong emotions she feels in response to the world around her. Vivid in color and composition, and appearing almost playful at first, Yates' work surprises the viewer as the depth of her convictions emerge; the experience becomes visceral to the viewer, as it is to the artist. She is self-taught and lives near Roanoke, Virginia.

Art has always been an important part of my life. The past few years, it is the one thing that has helped me maintain a shred of my sanity.

$400 signed, limited edition
Dog Fight - $35,000 Original
$350 signed, limited edition
The Five Horsemen - $200,000 Original
$600 signed, limited edition

Johnson, Roberta "Bobi", 11
(815) 784-5152
(845) 679-4959
Pose For the Camera - $200 (prints)

Krajda, Steve, 97
(954) 753-7392
Fireworks - POR
Cyclone - $12,000
Stone Flowers - $10,000

Lahtinen, Silja Talikka, 64
(770) 993-3409
(845) 679-4959
Full Moon Fire - POR
Event & Explanation - $650
All the World Is Green - $1,200

Landoll, Scott, 81
(419) 621-5768
(845) 679-4959
Sunrise - $5,000

Lugo, Theresa, 96

Mensler, Peter, 36
(281) 421-9021
(845) 679-4959
Pennypacker - $450
Homily - $600

Meotti, Valerie, 101
www.artbyvmeotti.com
(845) 679-4959
Eye Has It - $1,500
River Rock 1 - $1,250
River Rock 2 - $1,250

Moncayo, Yolanda, 81

Motyl-Palffy, Viola, 52-53
Dr. V. Barbagallo
0031-751-70-867
(845) 679-4959
Untitled I - $3,500
Untitled II - $3,500
Untitled III - $3,500

Nevers, Lorraine Florenze, 24-25
(973) 701-0251
(845) 679-4959
The Filtering Pitcher - $6,000
Freedom Warrior - $1,000
Hunger - $2,500

Oks, Leon, 16
(845) 679-4959
Jealousy I - $15,000
Dream I - $15,000

Oshima, Naoko, 127
(845) 679-4959
2 Bats Eating Figs - $800
Seal Family - $1,200
Cheetah Family - $1,200

Paik, Rosa Kim, 35
(856) 343-8229
(845) 679-4959
Geo-Abstraction II, London - $5,000
Geo-Abstraction II, Hadera - $2,500
Geo-Abstraction II, Amman - $5,000

Pantell, Richard, 40-47
(845) 679-4959

Peters, John, 84
Agent: Claudia French
(800) 247-5974
Adele - $3,800
Moon Blossoms #2 - $4,200
Dirk - $3,800
Short Skirt - $1,600

Poniarski, Ruth, 121
(845) 679-4959
Who's Game #3 - $3,000
Dream - $3,000
Private Moment - $1,800

Quarles, Oscar, 51
(917) 915-5616
(845) 679-4959
Springtime Glance - NFS
Autumn Thoughts - NFS
Hurricane Beauty - NFS

Raissa, Latych, 28-33
(818) 667-4008
(845) 679-4959
Moment - $5,000
Minstrel - $8,000
Muse - $8,000
Forest - $7,000
Squash - $7,000
Celebration - $10,000
Pass Civilization - $7,000

Rath, Louise Link, 98-99
www.louiselinkrath.com
llrathart@verizon.net
(845) 679-4959
Sky Light - $2,400
Summer Wealth - NFS
Wing Span - Giclees available
Early Morning Glory - Giclees available

Richards, Carl, 143
(508) 385-2444
Ambigue - $500
Artifaxia - $500
Incipience - $900

Rodriguez, Ernesto A., 27
(212) 795-6286
(845) 679-4959
Still - $700
Burst - $2,000

Romero, Francisco, 67-68
(915) 886-4115
(845) 679-4959
Cuando Calienta El Sol - $3,000
Fat Frida - $2,500
Elvira - $2,000
The Cat - SOLD

Sakhai, Michelle, 130
(516) 776-2111
Golf Course - POR
Yellow Sky - POR
Garden City - POR

Schmid, Eliza, 140

Schweininger, Helga, 126
(845) 679-4959
No. 91 Feeling Free - POR
No. 96 Midnight Ballet - POR
No. 57 Dusk Landing - POR

Seggebruch, Patricia, 37
www.pbsartist.com
(360) 239-8081
(845) 679-4959
Monet 2006 - $2,200
Encaustic Blue - $1,900
Rothko in Magenta - $2,200

Sherrod, Philip, 92-93

Shvartsakh, Tatyana, 134
(717) 533-2272
(845) 679-4959
Dark and Light - $350
Mystery of Ancient Egypt - $350

Smith, Sally Giddings , 56
(802) 223-4971
(845) 679-4959
Dancing on the Brink of the World - $150 Giclee
Foggy Dawn - $950

Sparrow, Alison, 100
(313) 885-6967
Chickens (Doe Si Doe) - NFS
Sunflowers - NFS

Staub, Carol, 82-83
www.carolstaub.com
(908) 803-9229
(845) 679-4959
Intuitive - $2,000
Blue on Blue - $2,000
Sidewalk Series I - $3,000
Sidewalk Series IV - $2,000
Sidewalk Series VIII - $2,000

Stephens, Clay, 26
(407) 384-8608
(845) 679-4959
Sunset Stallion - $2,500
Ice Dreams - $1,700
Spring Romp - $1,600

Stevens, Carl, 95
(410) 790-2195
(845) 679-4959
Tied Up - $1,800
By The River - $1,800
3 Trumpeters - $2,400

Stott, Mounira, 10
(845) 679-4959
Across the RIver - $825

Stovall, Rodney, 57
(314) 533-1723
(845) 679-4959
Former Glory - $900
The Neighborhood - $875

Stroup, Irina, 139
(530) 722-0764
(845) 679-4959
Rose and Hose - $500
Whisper and Glow - $300
Anticipation - $500

Tarasiewicz, Tamara, 124-125
(845) 679-4959
Dandelions - $8,000
Baby's Breath - $9,000
Montain Illusion - $12,000
Power of Nature - $4,500

Tayber, Pavel, 54-55
(650) 566-1758
(845) 679-4959
Three Girls - $6,000
The Unfinished Parade - $4,500
Margarita - $5,000
The Broken Mirror - $6,000

Thomsen, Margaret Anne, 80
(212) 255-9050
(845) 679-4959
Ruth and Boaz - NFS
Harlequin - NFS
Harvard Divinity School - NFS

Ulman, Alison, 58-59

Vasilakos, Jennifer, 138
(561) 504-9080
(845) 679-4959
Mindscape - POR
The Bridge - POR
Paradise - POR

Weir, Robert, 38-39
(845) 679-4959
Fire Dancer - $1,900
Steroid Man - $2,200
The Lady Is a Tramp - $1,800
Madame X - $2,600
Fickle Lady - $4,600

Whitman, Karen, 41-46
(845) 679-4959

Williams, 142

Winick, Bernyce Alpert, 136-137
(516) 374-6415
(845) 679-4959
Vibráto - $5,000
Brióso - $18,000
Allegrétto - $16,000
Expressióne $16,000

Winkler, Jeffrey Dean, 65
(845) 679-4959
Upon Waking - $800
No Birds - $750
Safely Fluttering in the Backward North - $2,200

Yates, Sadie, 144-145
(540) 947-5601
(845) 679-4959
Self Portrait Today - $4,400
Family Tree - $3,500
Wide Eyed Jesus - $100 signed prints

Yung, Anna, 135

Zhang, Hongnian, 102-115
(914) 679-4411